HOW TO DRAW
THE HUMAN FIGURE
A COMPLETE GUIDE

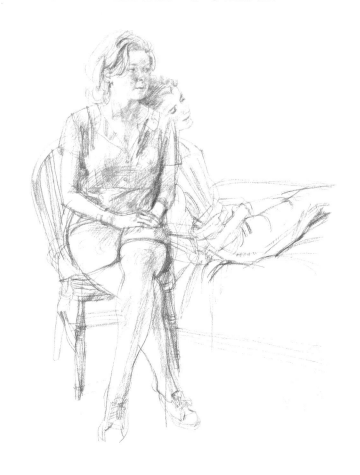

HOW TO DRAW
THE HUMAN
FIGURE
A COMPLETE GUIDE

John Raynes A.R.C.A.
and Jody Raynes

p

This is a Parragon Book
First published in 2000

Parragon
Queen Street House
4 Queen Street
Bath BA1 1HE UK

Drawings and paintings
by John Raynes and Jody Raynes

Designed, produced and packaged by
Stonecastle Graphics Limited
Edited by Philip de Ste. Croix

ISBN 0-75253-666-4

Printed in Italy

Contents

Introduction 6

A Brief History of Figure Drawing 8

Getting Started 12

Introduction

OF ALL subjects, it is our own selves that most provoke our curiosity. We are fascinated by our bodies, our minds, their nature, and their collaboration which produces the surprising result of – a person, walking around, interacting with other people, and wondering about him or herself. The spoken and written languages we use allow us to gather together and preserve any thoughts that we have, and to share them with other people. Drawing is a language of enormous breadth, too great to try to encompass here, but one amongst its many disciplines, or dialects, is *objective drawing*.

Objective drawing is the process of making a drawing of something, so that the drawing resembles the subject closely. It is a process well suited to the act of self-enquiry, and it is to this activity that we refer when we talk about figure drawing.

People have been drawing one another for an extremely long time. Since the advent of cheap photographic processes, the practice of objective drawing has certainly lost its practical descriptive role, yet the potential enjoyment and emotional power of drawings is undiminished by time. If anything, it is celebrated and valued as a timeless activity. The wonder of drawing is grounded in its absolute simplicity. All that is needed is a surface, and an instrument which will make marks on it. From these can be fashioned, quickly and efficiently, a picture of a person which is so much more than the sum of its parts. It should be simple...but, more than most other creative processes, this challenge is particularly feared by the creator. Many people are so certain of their ineptitude at drawing, so sure that competence is decided by the dice-roll of natural ability, that an innate desire to draw is never allowed to develop.

It is not the case that drawings of people are the hardest to make; rather they are the easiest to judge. We are so familiar with the structure and layout of our own bodies that we notice inaccuracies immediately. (A drawing of a tree, for example, might have an extra limb added to fill a gap, an adjustment which will go unnoticed; an additional leg or elbow in a figure drawing, however, would look very peculiar). This acuity is a double-edged sword, though. The mind's image is not so simple as a picture. Imagine the face of somebody dear to you, a face that you would recognize instantly from among a hundred others, and then try to draw it from memory. Suddenly, that precise relationship between nose and mouth, or the direction of that

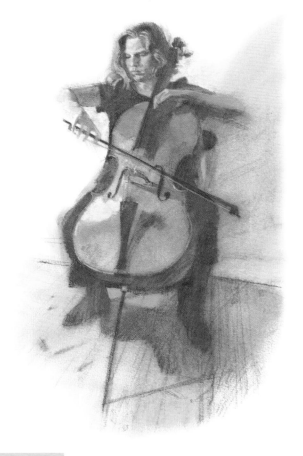

utterly original jaw line, become exasperatingly difficult to capture. What you had thought was a clear picture in your head is actually a sea of snatched fragments of memory, impossible to collate: the harder you concentrate, the more intangible it becomes.

When we draw somebody from observation, there is still a powerful inclination to try to draw from memory, and place too much significance on the parts that we consider important: the head can end up too large for the body, the face too big for the head, features too big for the face. Paradoxically, it is the fact that we think we *do* instinctively know what people look like that becomes the biggest obstacle to drawing what we actually see. Attempts to draw completely from memory, although often held to be a formidable skill, are generally uninteresting: science looks askance at the concept of a photographic memory, which would be required to retain and draw upon the deluge of information you process when you draw a person from life. It is precisely these elements that we are most interested in, the subtle differences between people, that are most difficult to remember.

The overwhelming emphasis of this book is to encourage you to believe what your eyes are telling you, and not to make adjustments to allow for what your experience tells you is correct. Drawing *is* difficult, and drawing well can (should) be mentally exhausting...but also exhilarating. We do not offer any tricks; this is not because we are puritanical about demanding effort, just that the correct decision in one situation is unlikely to apply in another, and too many hints about how to draw certain bits and pieces of the body can run contrary to the process of close observation.

The best drawings you make are invariably the ones that you were least concerned about making. This is not meant as an encouragement to be

lackadaisical about your drawing, but as a reminder that too much worry about 'getting a likeness', or making a picture that people will like, can obstruct the fundamental principle, which is *looking*. Draw truthfully what you see and the likeness will come. The same applies to materials. We will be discussing a variety of artists' materials throughout the book, but a rule of thumb concerning materials, especially paper, is that whatever it is, get a lot of it. It is much better to buy a number of sheets of cheaper paper, which are potentially disposable, than a few sheets of expensive paper, because this will stop you from feeling inhibited about using it (I *must* do a good drawing, because this paper cost me...etc.). Above all, enjoy your drawing, enjoy the process for itself, and when you get some successes out of it (you will), then enjoy the realization that you are winning.

A Brief History of Figure Drawing

EOPLE HAVE been drawing one another for, well, forever, so this account must either be very brief, or focus more closely on the drawings which offer us the most. The beauty, economy, and emotional fluency of many very early, sometimes prehistoric, drawings that we may see in museums, or preserved untouched for millennia on the walls of ancient caves around the world, can not be doubted nor emphasized enthusiastically enough. These graphic statements, made so long ago, are capable, whatever their original intention, of speaking very clearly to us now about our current concerns, and are a joy to observe. An investigation, however, into prehistoric, Ancient Egyptian or Graeco-Roman artefacts is not our concern here – that we shall leave to the professionals. Undertaking some research of your own into these areas of art history would be very profitable, nonetheless.

The first time that figurative drawings were created that purported to be accurate descriptions of what the eye actually observed was with the beginning of the intellectual flourish in Europe that is now known as the Renaissance. Prior to this period, drawings had been fundamentally symbolic, not attempting to depict the world as it was actually seen. The Renaissance is an important period of European history which began in Italy in the fourteenth century, and is considered as marking the birth of modern times – an accelerated period of learning and enquiry into all manner of disciplines:

science, art, literature, music and technology. All these topics co-existed more closely together than they do today, and the relevance for us is that a Renaissance artist was happy to pursue technical and scientific enquiries to inform his creative discoveries. The most famous example is the one-man phenomenon called Leonardo da Vinci, who was held in the highest esteem by his contemporaries (at least the excitable sixteenth

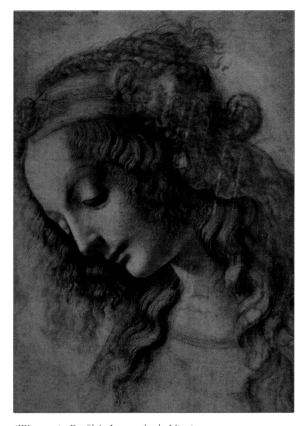

'Woman in Profile', Leonardo da Vinci.

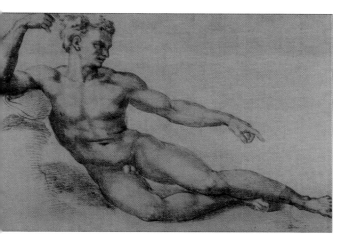

'Nude Study', Michelangelo Buonarroti.

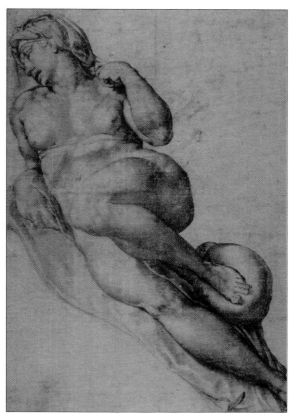

'Nude Study', Michelangelo Buonarroti.

century art historian Vasari) as simultaneously artist, architect and inventor. Leonardo, and his rival Michelangelo Buonarroti, shared the artistic goal of making paintings and sculptures that were as close to divinity as possible. This religious impetus famously inspired Michelangelo singlehandedly to undertake to paint the ceiling of the Sistine Chapel, against all odds, and prompted artists tirelessly to investigate the world around them, particularly the most divine icon, the human figure. The advancements in the visual understanding of the figure, and in how it may be rendered, made by these early Renaissance artists are astonishing, and they bequeath to us some of the most subtly sophisticated and beautiful drawings in existence.

The Italian celebration of Christianity was one of grand gestures, of allegories lavishly and imaginatively realized; the human figure, though meticulously observed, was invariably standardized and represented in a form that was considered ideal to contemporary tastes. At the same time, in northern Europe, while religious subjects were still important, genre painting, the study of everyday life, and portraiture, were more common themes. This meant that the depiction of people was more realistically contemporary, and more personal. The

German artist, Hans Holbein the Younger, made drawings for his portrait paintings that were clearly highly valued in their own right at the time; today, the precision with which they describe the disposition and relationships of their subjects seems breathtaking. It is perhaps the northern artists whose sentiments are closest to ours today, though it is interesting to see how the popularity of the Renaissance masters has waxed and waned throughout later history. In the late eighteenth century the work of artists such as Jean-Auguste Dominique Ingres, which reflected contemporary Romantic interest in Roman culture, celebrated the Florentine artists' Romanticism. Although Ingres is rightfully considered today among the greatest draughtsmen of all, the work of that time shows no interest in the individuality of the people depicted.

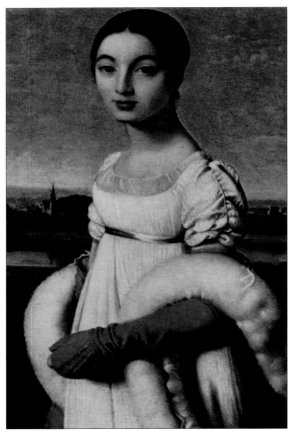

'Portrait of Mademoiselle Riviére' (1805), Jean A.D. Ingres.

More recently, artists have approached the human figure in a great variety of ways. At the end of the Victorian era, an explosion of new ideas about perception flooded the whole of art, and maverick artists divined new ways of looking. Paul Cézanne (later to be weightily credited with the invention of modern art) found that by treating his human subject as nothing more than a solid volume, like any other object, he could paradoxically communicate character and disposition more effectively. This principle was in part espoused by the artists who are now known as the Impressionists. At much the same time, in Austria, a school of artists now referred to as the Viennese Secessionists were creating unprecedented and, even now, unique art. Gustav Klimt combined refined and delicate objective drawing with dazzlingly patterned surfaces in his expression of the bleaker aspects of human life, and his protegé and successor Egon Schiele brought to these a precocious genius. Though hardly a 'rounded' artist, Schiele's visions of mortality and sexual energy were crafted with a phenomenal

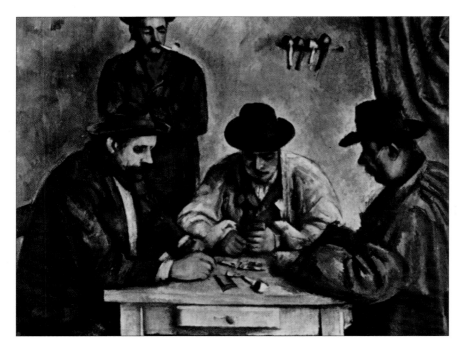

'Study for Card Players',
Paul Cézanne.

'The Card Players',
Paul Cézanne.

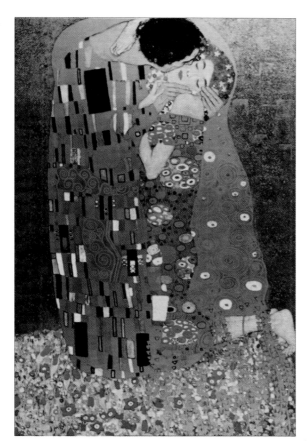

'The Kiss', Gustav Klimt.

radically distant from 'traditional' art, they are simply tools, and much of the art being produced by young artists today has as its subject the same preoccupation that art has always addressed: the human being and what it is to be one. Though outside the scope of this book, which is specifically about drawing the human figure in space, let your investigations lead you into all aspects of art. It may be surprising where you find the most satisfactory answers to the oldest questions.

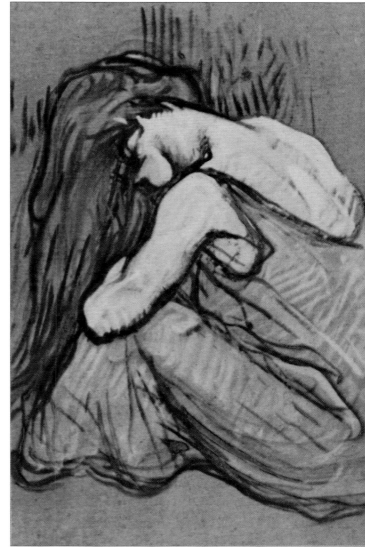

'Woman Combing Her Hair', Henri de Toulouse-Lautrec.

drawing ability. His drawings are a demonstration of superb economy, in which just a few lines and marks describe an often distorted human figure in its full complexity.

Our own century has been dominated by fully Expressionist art, which frequently discards the notion of objective drawing. The greatest practitioners of all, however, Pablo Picasso and Henri Matisse, founded their Expressionist work on a relaxed fluency in objective drawing; even Picasso's most distorted pieces are just that, distortions; they identify and magnify the essence of his subject.

The human figure has played a huge role in art this century, perhaps more so now than ever before. While video and electronic processes may seem

Getting Started

THIS BOOK is composed, from the very start, as a series of consecutive projects. We recommend that you approach them more or less in order, especially for the first few chapters, as it is important to deal with the basics of solid forms and outlines before you start to employ other techniques, like variations in lighting.

We have eschewed the traditional chapter on materials for two reasons. Firstly, as the book is mostly about drawing, rather than painting or using other materials, it seems unnecessary to suggest that you should develop a full understanding of materials before you start to do anything. Secondly, we feel that choice of media is a personal matter; experiment by all means, but remember that your materials are your tools, not your subject. Use whatever you are most comfortable with, materials that allow your attention to be wholly focused on your subject. In any case, as the projects develop, we will introduce various other media, especially when paint is used.

To begin with, we suggest that you have as large a quantity of paper available as you can lay your hands on, of a variety of sizes, but certainly up to A2 or larger; some willow charcoal, which is preferable to the compressed sort as it is easily erased and moved about on the paper; some fixative, for the same reason (tip: buy the little bottles and a mouth spray from an art shop, as the aerosol spray is ferociously expensive and highly toxic in an unventilated area, and hair spray – which is popular in art schools – loses its effect after about a week); and a variety of graphite sticks and pencils. If you like to draw in colour, there is a huge variety of products available; we favour the simple Conté pencils and hard pastels.

You will need models. Persuade friends and family to pose for you. Despite initial reticence, many people are actually quite pleased to be drawn. Many of the projects are based on fully or partially clothed figures. You could complete all the projects

without recourse to fully nude models, though bathing costumes would be preferable to baggy clothes in most cases.

Whenever possible, professional models are recommended, however, as there is actually a great deal of skill in modelling for an artist, and professionals will be able to help you out with poses if you tell them what you want to do. *Remember to give them regular breaks.* You may be engrossed in the work, but your model probably isn't, and holding poses can be very tiring.

The best place to find professional models is at an art school, so if there is one near you, get in touch. If not, many models will advertise in the classified ads section of local newspapers. It is often worthwhile to form a drawing group with some others, as the cost of the model can be shared, and independent criticism of your work can also be very useful.

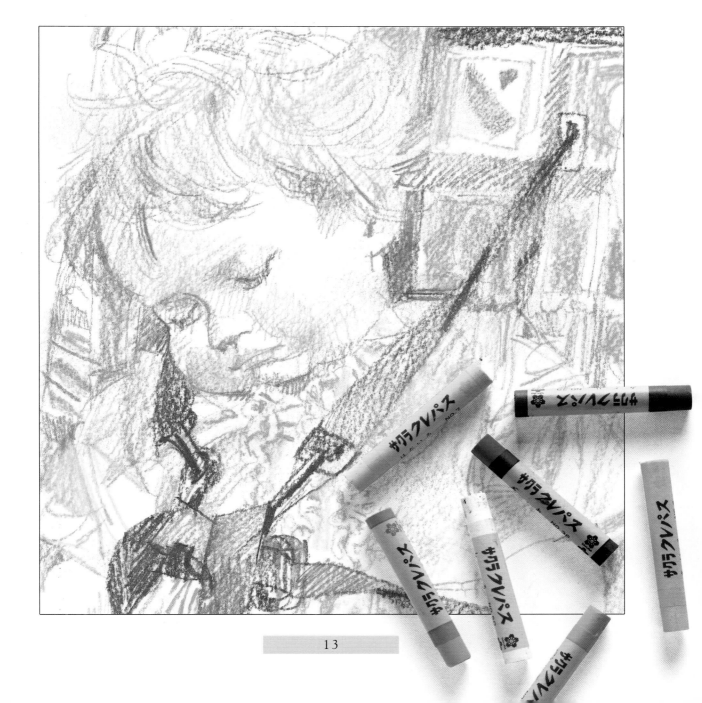

Form

The first challenge in figure drawing is to see the whole figure as one shape. Our prior knowledge of the figure as an individual person encourages us to see it as a collection of various parts, whose relative importance is skewed by experience. We might be particularly interested in eyes, but not in elbows, and if we draw in this way then the resulting drawings will never be cohesive. In this first section, then, we ask you to forget totally that your model is a living and thinking person, and simply treat him or her as an assembly of forms. Looked at in this dispassionate way, it is surprising how insignificant the separate details actually seem.

As the projects develop, they will address the reality of a figure as a *three*-dimensional form, which contains volume. These projects are among the most important in the book, as translating a three-dimensional object into a two-dimensional picture is the foundation of objective drawing. To this end, don't worry too much about making your drawings look like people at this stage. If your construction lines have to be redrawn so many times that in the end you cannot see much else, then fine; better this than a neater, but poorly observed, drawing. Remember: it is what you learn while making the drawing that matters, and if you realize this then you will end up with good drawings in the long term.

Building the Figure

SILHOUETTES

*P*ROBABLY THE first and most essential skill to acquire when drawing the human figure is the ability to look past the detail and see the shape in its entirety.

To this end, we suggest that you spend some time tracing the outlines of figures from photographs – any photographs will do, as long as they show the whole figure. Try to box in these outlines with rectangles or squares or triangles. The regular shapes can be halved or quartered to make their relative proportions clear and to draw attention to where the main bulk of each figure is situated in the geometrical enclosure. If you notice a shape which would tightly enclose the main bulk, draw this too, and note any features of the outline which follow a straight line or even a regular curve. The reason why these boxes are helpful is that your eye is better able to see the relative proportions of a rectangle than it can judge the length and breadth of a loose outline.

To demonstrate how the eye (really the brain, via the eye) loves shape rather than dimension, look at the pairs of intersecting lines 1a & 1b below: are they the same length? It is not easy to be sure, but add the diagonal and there is no doubt – 2a is taller, with a shorter base, than 2b. You can use the same technique when assessing the upper and lower lengths of a bent arm: just complete the triangle with an imaginary line from shoulder to wrist and check that your drawing makes the identical triangle.

This outline is fully recognizable as a figure, even though there are no apparently obvious shapes. The 'quartering' of the whole shape keeps each segment in proportion to the others.

The proportion of an entire shape is easier to establish than the relative proportion of individual lines.

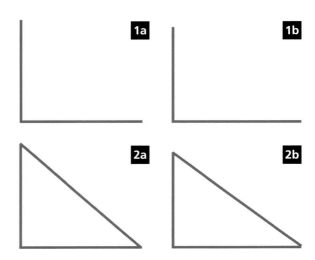

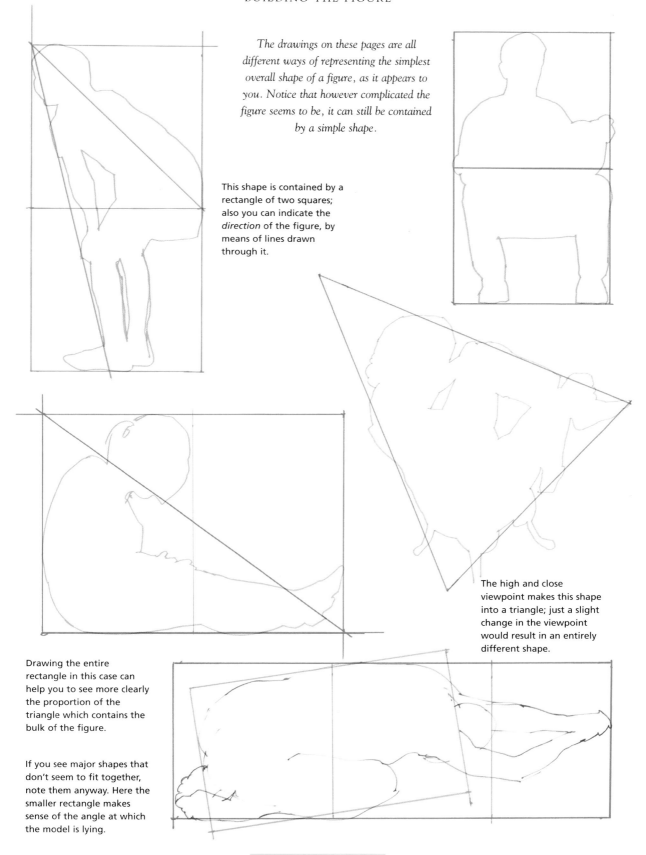

The drawings on these pages are all different ways of representing the simplest overall shape of a figure, as it appears to you. Notice that however complicated the figure seems to be, it can still be contained by a simple shape.

This shape is contained by a rectangle of two squares; also you can indicate the *direction* of the figure, by means of lines drawn through it.

The high and close viewpoint makes this shape into a triangle; just a slight change in the viewpoint would result in an entirely different shape.

Drawing the entire rectangle in this case can help you to see more clearly the proportion of the triangle which contains the bulk of the figure.

If you see major shapes that don't seem to fit together, note them anyway. Here the smaller rectangle makes sense of the angle at which the model is lying.

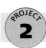

COMPACT SHAPES

*I*F YOU were asked to describe the human figure you would, understandably, probably focus on the details; the long arms and legs, the features of the face, the hands and fingers. These are the parts that we use to recognize one another quickly – the purest expression of this is the stick-man drawing. The purpose of the exercise on this page is to learn to resist the tendency to overstate the importance of all these separates bits and pieces, and to see the body as one entire form.

Ask your model to assume contained, huddled, poses on the floor, with legs and arms intertwined so that the appearance is of a solid block; the opposite of a stick-man. Make rapid drawings, taking no more than 15 minutes each, and quickly try to find the smallest simple shape that will contain the bulk of the figure. If you can find an imaginary square or rectangle that fits closely around the figure, then

draw it – the objective is to see the simplest sort of solid form.

Once you have identified the overall shape of the figure, it is easier to draw into it without getting sidetracked by individual parts of the body. Instead of drawing lines indicating divisions that you know to exist, such as the meeting of the thighs with the chest of a hunched figure, draw the parts that have deviated most from your original form: imagine yourself to be a sculptor knocking chunks from a large block of stone. Draw enthusiastically as if you were attacking a lump of rock with a chisel too; this is why charcoal is the best material to use, as it makes a large mark quickly, which also can be easily removed. No marks are sacred, and if, after a few minutes of drawing, you find that your first construction marks are wrong, then change them, and adjust the rest of the drawing accordingly.

By applying the methods of the last project, the contained shape of this pose can easily be seen as a squat rectangle.

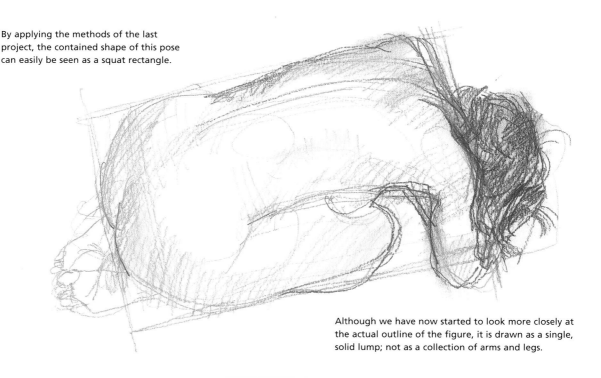

Although we have now started to look more closely at the actual outline of the figure, it is drawn as a single, solid lump; not as a collection of arms and legs.

Heavy use of tone here establishes this shape as something like a building. The normal distinctions between body parts are made redundant.

A complex, convolutedly enwrapped pose can take on the simple form of a boulder.

This pose, although slightly more open, is composed simply of three solid bulks. The lower legs, as one single form, are like a smaller version of the torso.

If an obvious shape doesn't enclose all of the figure, as is the case with this stray foot, nevertheless draw it anyway – it will still help you to determine the overall shape.

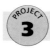

LONG AND LOW

OR THIS project the model can unwind and extend, while still staying close to the floor. The visualization to employ here is one of a long, low building. Again, as in the last project, stability is not a problem for the model, a prone figure cannot fall down.

The most stable position for a figure, of course, is flat on the floor face down or face up. You should try one or the other of these, first making sure that your model has a reasonably comfortable surface to lie on, but not so soft as to allow the body to sink into it – the idea is to have a structure rising from a flat plane.

For the step-by-step drawing, we have taken the metaphor of a low building just one step further, by getting the model to lie on his side. This is still fairly stable, but perhaps we are now thinking about a *two*-storey building, and it is not quite as easy for a human figure to relax in this pose as it is flat on one's back. This model has bent his legs to achieve

stability, but even if he lost his balance, it would only result in him rolling on to his front or back.

The model is lying on a rectangle of neoprene, the perspective of which usefully defines the floor area occupied; a mattress would fulfil the same function. Draw in the imagined building as we have and try to keep in the forefront of your mind the idea of walls perpendicular to the base with a flat roof extending in the same plane as the floor.

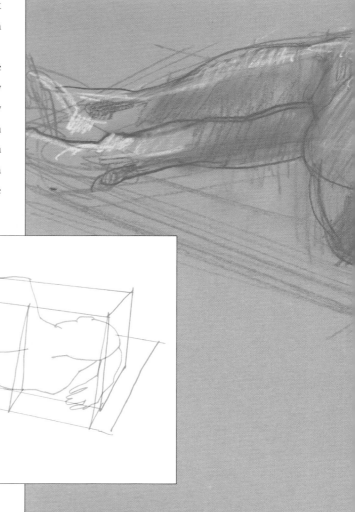

This shape can be analogized as
a rising, balancing building. The arm
and legs extend across the plane of the
'wall' – the back – and prevent it from rolling over.

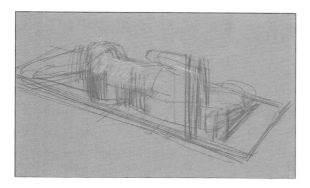

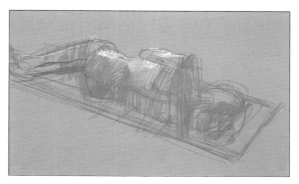

Imagine yourself to be looking down on a huge building, and work out its ground-plan: this is where the presence of a regular shape to refer to, such as a mattress, will be useful. Draw the edges where the major planes change, as you would draw the vertices between the walls of a building.

A lighter coloured pastel is used to indicate the lit areas of the structure, and dark, rubbed charcoal for the shadowed areas. Looking at the form in this simple way, of tonal variations, at the same time as observing and drawing the edges, can help you to discern its overall volume.

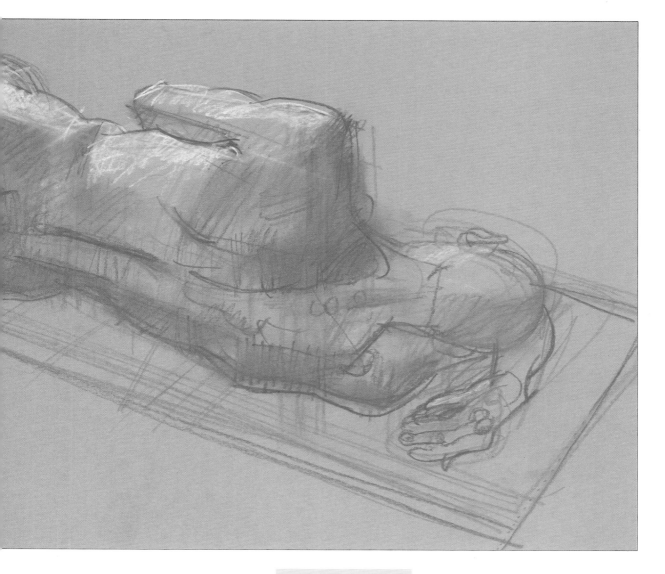

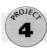

LOW AND HIGH RISE

*N*OW THE long, low building has a high rise block at one end. Another way to visualize the framework is to imagine the overall shape of the first cutdown block of stone from which a sculptor could do the final carving (even though, in this case, the head and a hand or two have escaped the block, in order that we should be able to enclose the legs and torso more closely)!

We are not suggesting that you draw this framework with a ruler and coloured pencils as here; the diagram is intended to represent your thought processes rather than an actual step in the method of drawing. Nevertheless, as you can see in the stage drawings on this spread, some similar but lighter freehand lines defining the shape are very useful in setting up the drawing. You should never be afraid of making early construction lines: if they are lightly drawn, they will soon be submerged as the drawing progresses. Even if they do remain detectable, we prefer not to erase them, as their presence reveals the artist's progress and thought processes and imparts a feeling of liveliness to the drawing.

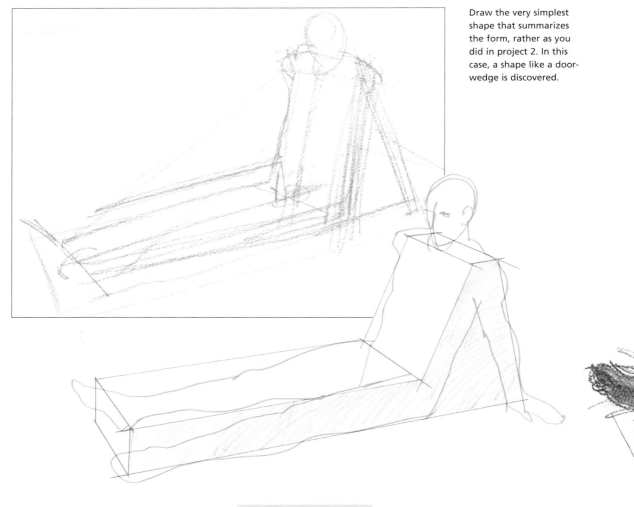

Draw the very simplest shape that summarizes the form, rather as you did in project 2. In this case, a shape like a door-wedge is discovered.

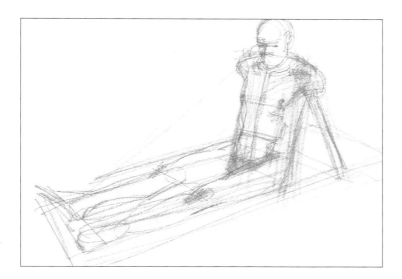

Start to look at the shapes which define this particular pose. Here, it is the fact that the torso is being supported by the arms that is important; the arm is drawn in more or less as a strut; if it were removed, then the model would collapse backwards.

Attention is concentrated on the triangle created by the arm, the side of the body, and the floor. It is especially important that the hands correspond with the floor plane established by the legs and pelvis.

As the figure emerges from the structural grid, the torso-supporting strut becomes more arm-like and the forms are rounded out to acquire their individual shapes.

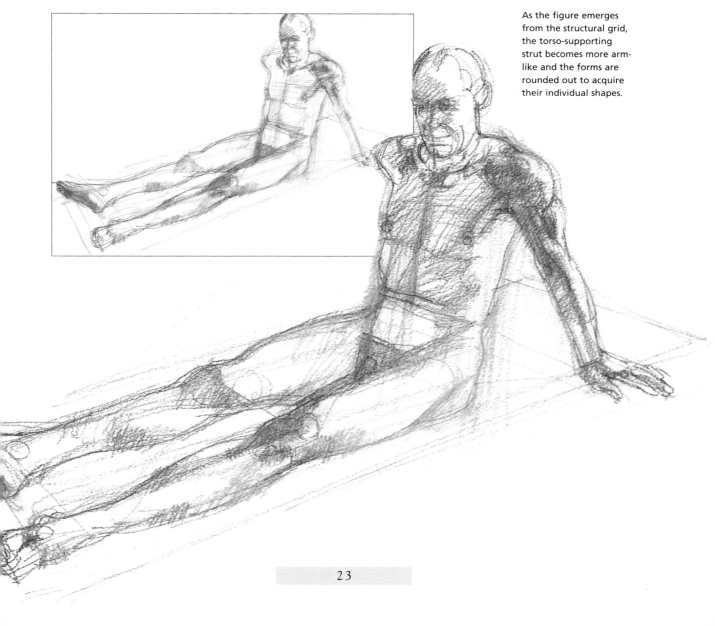

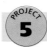

TRIANGULAR BUILDING

PROJECT 5

*A*S THE figure opens out, as legs and arms unfold, its obvious structure changes from that of a solid block to a more complex collusion of forms. For this project, ask your model to lift herself up a little compared to her previous poses. Keep the drawings rapid, ten minutes each or thereabouts. Kneeling, or with its legs tucked underneath the body, the figure becomes a slightly more precarious structure. No longer is the model as near to the floor as she can be: she must balance. Simply put, she *can* fall over. Therefore the new emphasis in these drawings should be on how she is able to stay upright.

As previously mentioned, the structure cannot be so readily compared to a simple rectangular block; do not be tempted, however, to revert to a 'stick-man' idea of the figure and then begin drawing everything in great detail. The simple form that will describe most of these poses is the pyramid, even though a large part of it may have to be imagined. The broad base provides stability (people sit like this on surprisingly steep gradients – look at people sitting outside on grassy slopes on a sunny day), and the structure tapers towards the top. When your model is sitting cross-legged, seen from the side her back will be at an angle inclined to the base of her legs – imagine a line drawn from her head to her knees and you have a fairly even pyramid.

With these drawings you will be beginning to face the complexities of the human figure, and while we have emphasized (probably rather a lot by now) that it is not a good idea to dwell on the details, they are *there*, and should not be completely ignored. As your model's face or hands are exposed to you, draw them – but pay no more attention to them in particular than to the overall structure.

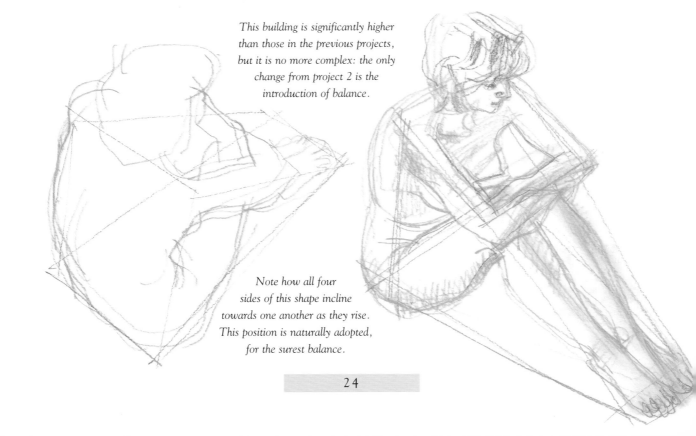

This building is significantly higher than those in the previous projects, but it is no more complex: the only change from project 2 is the introduction of balance.

Note how all four sides of this shape incline towards one another as they rise. This position is naturally adopted, for the surest balance.

In these cases, the head can be considered redundant to the overall shape, as it simply balances on the top of the 'pyramid' (more accurately, it is cantilevered out by the spinal musculature, but it isn't actually supporting anything). However, if arms and feet escape the shape, they may still be performing a supporting role, and will therefore need close attention paid to them.

Change the poses to uncover significant variations in the shape. In this pose, the model is sitting on a cushion, which has allowed her back to straighten, and the pose has become much more one of two parts, comprising the upright tower of her torso and the flatter building of her legs.

25

SEATED FIGURE

*T*HE LIKELIHOOD is that the best chance you will have to draw somebody is when they are sitting down. Sitting poses are often thought of as boring, because the figure is so passive and invariably symmetrical, and a chair can seem so uninteresting as to deserve little attention. Think of the chair as part of the person, however, and you have a structure which is similar to the 'buildings' that you have been dealing with already. For clarity, it would be best to use a fairly rigid chair with four individual legs in this project.

The first observation to make is that your model is no longer supporting himself, and if the chair was not holding him up, he would fall down. The chair

is as important a part of the structure as anything else. This may seem obvious, but it is surprising how often you see drawings in which the supporting structure has been glossed over or ignored, leaving a figure that seems to be floating. Your model and chair have effectively become one six-legged object, and, as before, the base needs to be clearly defined, to support the figure.

Try to see the space underneath the chair as a solid shape, whose corners are identified by its legs, and draw the shape the six legs describe on the floor; and as you draw the rising structure try to forget that the chair and your model are not the same object.

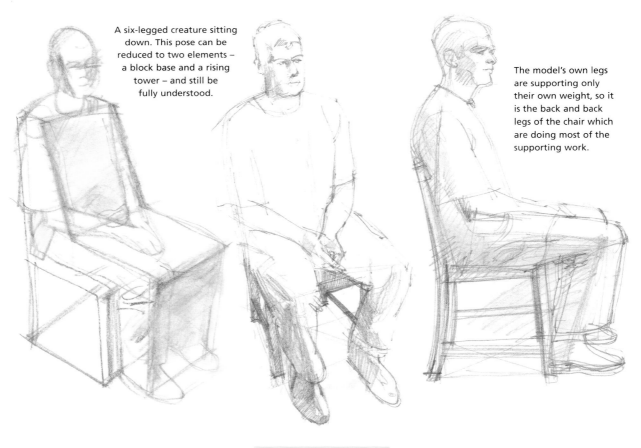

A six-legged creature sitting down. This pose can be reduced to two elements – a block base and a rising tower – and still be fully understood.

The model's own legs are supporting only their own weight, so it is the back and back legs of the chair which are doing most of the supporting work.

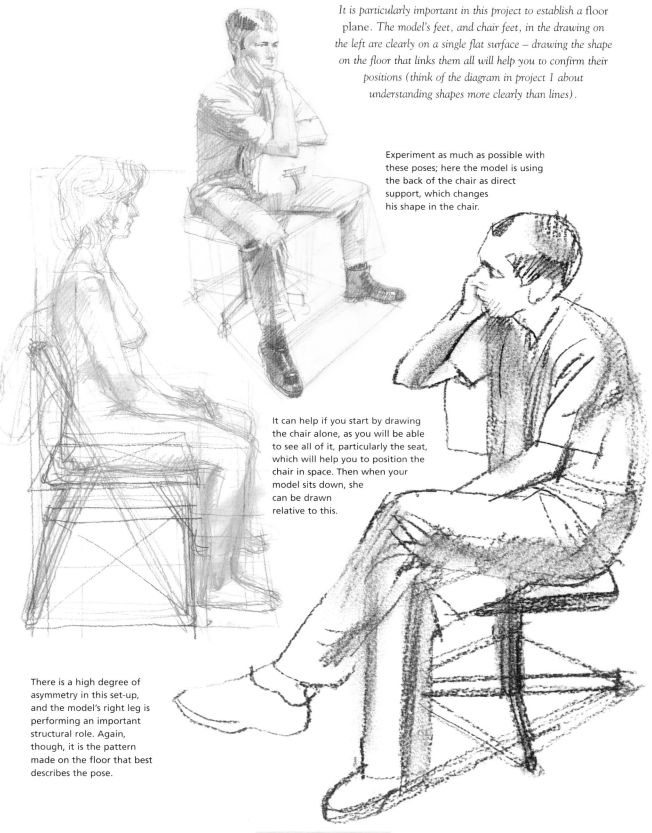

It is particularly important in this project to establish a floor plane. The model's feet, and chair feet, in the drawing on the left are clearly on a single flat surface – drawing the shape on the floor that links them all will help you to confirm their positions (think of the diagram in project 1 about understanding shapes more clearly than lines).

Experiment as much as possible with these poses; here the model is using the back of the chair as direct support, which changes his shape in the chair.

It can help if you start by drawing the chair alone, as you will be able to see all of it, particularly the seat, which will help you to position the chair in space. Then when your model sits down, she can be drawn relative to this.

There is a high degree of asymmetry in this set-up, and the model's right leg is performing an important structural role. Again, though, it is the pattern made on the floor that best describes the pose.

27

SEATED CLOTHED

*E*VERYTHING THAT we asked you to do in project 5 applies equally in this project. The only difference is that now the model is to be draped or very simply clothed, which to some degree visually unites the figure even more securely with the chair.

In general we suggest that for these first projects you need not use any other than simple media, which are easy and cheap to procure, such as pencil, charcoal, chalk and the like. However, the method used in these step-by-step drawings is so fail-safe and tolerant of easy alteration that we think that it is worth adding to your armoury at this early stage, even though it does involve oil paint and a solvent.

The paint is available in the form of a bar, a solid stick of oil paint that you prepare for use by slicing off a layer of skin to expose the softer interior. You can then use it to draw boldly the main shapes and directions that you see in the pose. A rag dipped in turpentine is then used to modify and soften these bold shapes, which can then be drawn into with a soft pencil or graphite stick. The beauty of this method is that there is no need to wait for the paint or turps to dry – you can draw over it immediately. Also, this stage can be wiped out and modified with further wipes of the turpsy rag which allows you to make changes until you are satisfied that you have achieved the best solution.

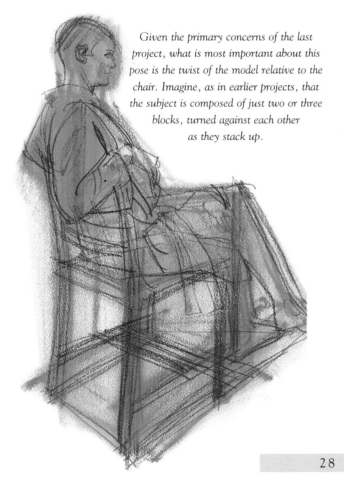

Given the primary concerns of the last project, what is most important about this pose is the twist of the model relative to the chair. Imagine, as in earlier projects, that the subject is composed of just two or three blocks, turned against each other as they stack up.

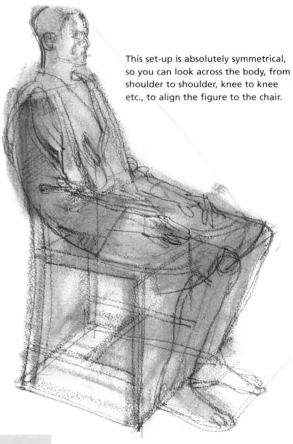

This set-up is absolutely symmetrical, so you can look across the body, from shoulder to shoulder, knee to knee etc., to align the figure to the chair.

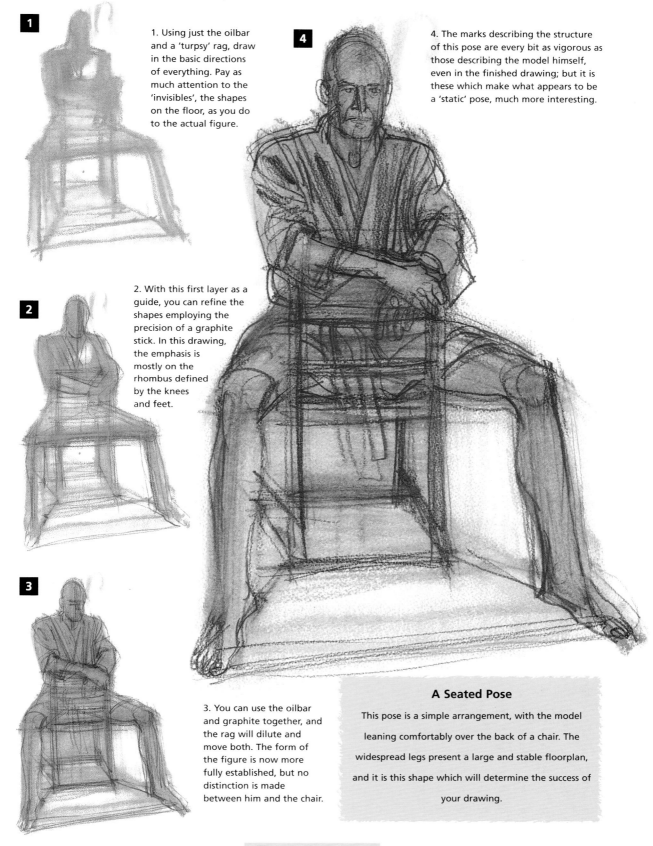

1

1. Using just the oilbar and a 'turpsy' rag, draw in the basic directions of everything. Pay as much attention to the 'invisibles', the shapes on the floor, as you do to the actual figure.

4

4. The marks describing the structure of this pose are every bit as vigorous as those describing the model himself, even in the finished drawing; but it is these which make what appears to be a 'static' pose, much more interesting.

2

2. With this first layer as a guide, you can refine the shapes employing the precision of a graphite stick. In this drawing, the emphasis is mostly on the rhombus defined by the knees and feet.

3

3. You can use the oilbar and graphite together, and the rag will dilute and move both. The form of the figure is now more fully established, but no distinction is made between him and the chair.

A Seated Pose

This pose is a simple arrangement, with the model leaning comfortably over the back of a chair. The widespread legs present a large and stable floorplan, and it is this shape which will determine the success of your drawing.

STANDING FIGURE 1

PROJECT 8

*S*TANDING ON two feet, which are really quite diminutive platforms, is a small miracle performed by humans everyday without any conscious effort. To draw this miracle convincingly you must have some understanding of how it is achieved. In response to balance messages received from the inner ears, continual adjustments are made to maintain the position of the head on the centre of gravity. If the weight is being supported equally on both feet, the line of this centre of gravity will descend from where the head joins the neck to a point on the ground equidistant between the feet.

Often, to relieve the strain of standing, we shift our weight more onto one leg and foot than the

A figure that stands of its own accord must always have its centre of gravity fall between its feet. This is shown here by the dominant vertical line.

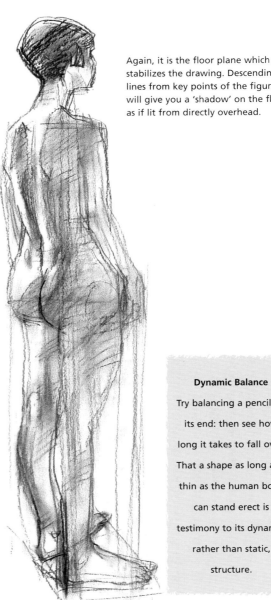

Again, it is the floor plane which stabilizes the drawing. Descending lines from key points of the figure will give you a 'shadow' on the floor, as if lit from directly overhead.

Dynamic Balance

Try balancing a pencil on its end: then see how long it takes to fall over. That a shape as long and thin as the human body can stand erect is testimony to its dynamic, rather than static, structure.

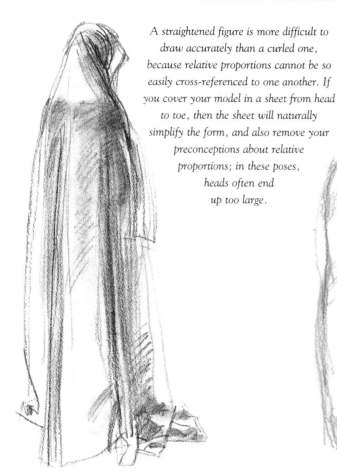

A straightened figure is more difficult to draw accurately than a curled one, because relative proportions cannot be so easily cross-referenced to one another. If you cover your model in a sheet from head to toe, then the sheet will naturally simplify the form, and also remove your preconceptions about relative proportions; in these poses, heads often end up too large.

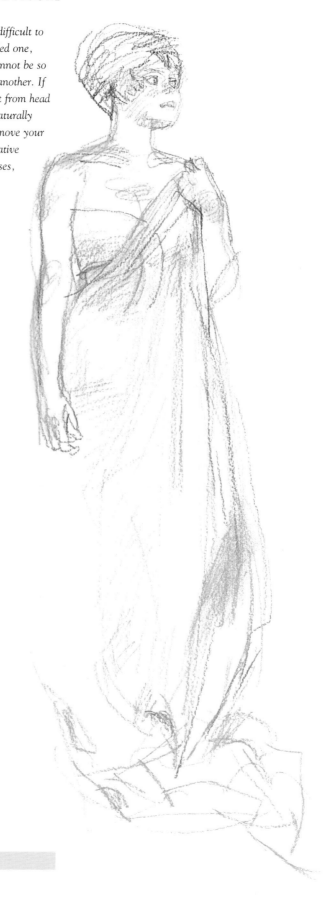

other; in this case the centre-of-gravity line shifts too, so that the head is now directly above the foot that is taking the weight.

Always check the positioning of the head when drawing the balanced standing figure; if a vertical from it falls outside the contact area of the feet, then the figure is either in a position of imbalance only maintained by muscular tension, is leaning or hanging on to some extended support, or is about to fall over.

There is one other situation in which the centre of balance is outside the feet contact areas. The condition of being about to fall over is one that immediately precedes movement, indeed walking and running are activities in which a state of continual falling and saving yourself from falling are intrinsic elements, of which more later.

STANDING FIGURE 2

*W*E HAVE allocated two projects to studying the balance of the upright standing figure because it is so important that you fully explore this most difficult trick that we human beings naturally perform every day with ease and without conscious thought.

This time ask your model to stand with his or her body weight almost entirely on one leg, with the arms involved in some way, perhaps crossed behind the head, or resting on the hips, or on a support outside the body, a chair back or similar. Try asking the model to lean against a wall or support some body weight on the arms. Poses like this may affect the simple one-foot balance, so check whether the vertical line from the centre of the head still meets the ground through the weight-bearing foot. Extending the arms away from the body also affects the weight distribution by shifting the centre of gravity slightly in the direction of the counter-weighting arms.

If, instead of being across your view, the swing of the pose is directly towards or away from you, it will be more difficult to spot the changed centre of gravity; the tell-tale line from the head may pass through both feet whether they are weight-bearing or not. In this case, you must depend on your judgment of depth to see which way the hips may be tilted to centre the body over the point of greatest support.

Drawing the figure's successful imitation of a skyscraper – by placing the head precisely on the centre of gravity or with small deviations from it – only works well if the pose is both relaxed and upright. Poses involving bending from the waist shift the centre of gravity much further away from the head. We will look at these in projects 19 & 21.

This model is hanging partially by one arm, and the asymmetry that her body experiences can be seen clearly in the tilt of her hips, against the opposite tilt of her shoulders.

This model is taking virtually all her weight on her left leg, and if her centre of gravity were projected onto the floor, then it would be under this leg.

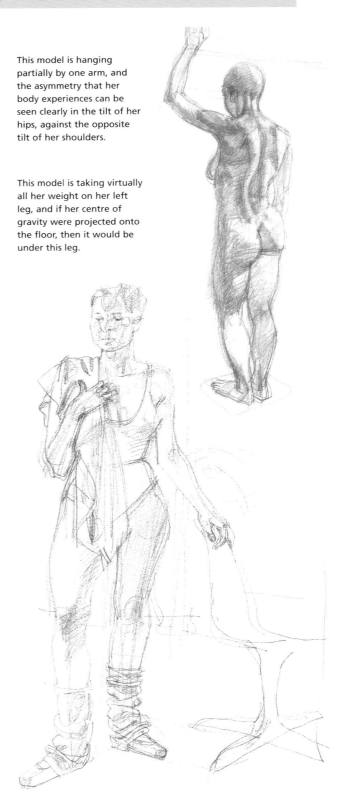

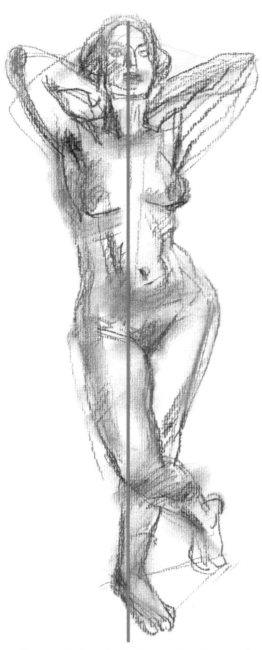

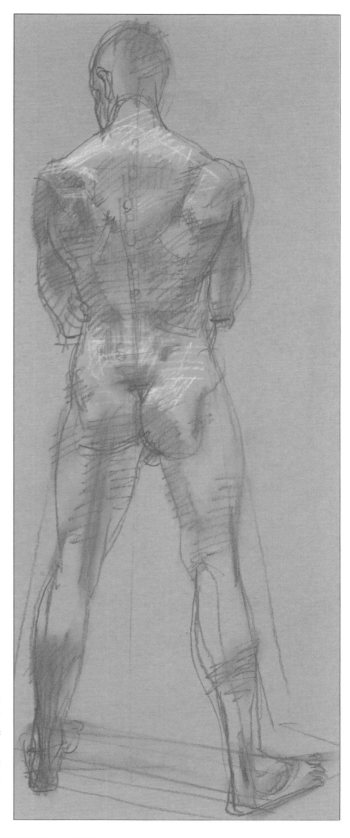

Because the figure in the drawing above is supporting herself on only one leg, her hips have shifted well out of the symmetrical plane of the body; it is these shifts that you should focus on when drawing. The figure on the right is standing about as solidly as possible, and it is the position of his feet on the floor which ensures this solid balance in the drawing. When you are drawing, if you find that you have wrongly estimated the size of the paper, and cannot fit the feet on, don't forget them – just stick another piece of paper on the bottom. Far better a strong drawing than a neat one.

Form and Solidity

RETURN TO BASICS

HERE IS sometimes a tendency for newcomers to figure drawing to be fearful of treating the human form as a solid like any other, to paint the head as if it were an apple, as Cézanne advised. Many of the forms on the human body are rounded: there are flat planes and grooves but no really sharp edges or corners. Natural objects such as fruit and vegetables show similar forms, and they have the advantage of staying still and they can be sliced to reveal their cross-sections.

This exercise is intended to encourage you to look again at subjects that you may have encountered as the elements of still life and to try,

above all, to render their solidity and volume by whatever means are most economical. Trying to copy the light and shade as you see it is not the only way to do this. Whenever we draw an outline we are making an invention; no lines actually exist around objects, their colour and tone just stops and is replaced by their background. Similarly, there is absolutely no reason why you should not invent lines to render other information, not only about the external shape but about the form too. Lines, for example, may be used to define contours and to track across the form tone can be added where none is seen in order to enhance the sense of solidity.

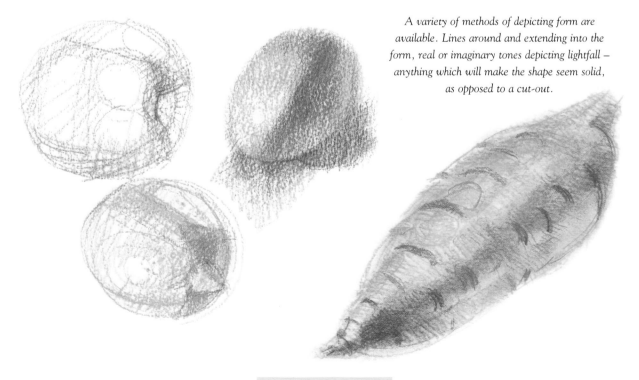

A variety of methods of depicting form are available. Lines around and extending into the form, real or imaginary tones depicting lightfall – anything which will make the shape seem solid, as opposed to a cut-out.

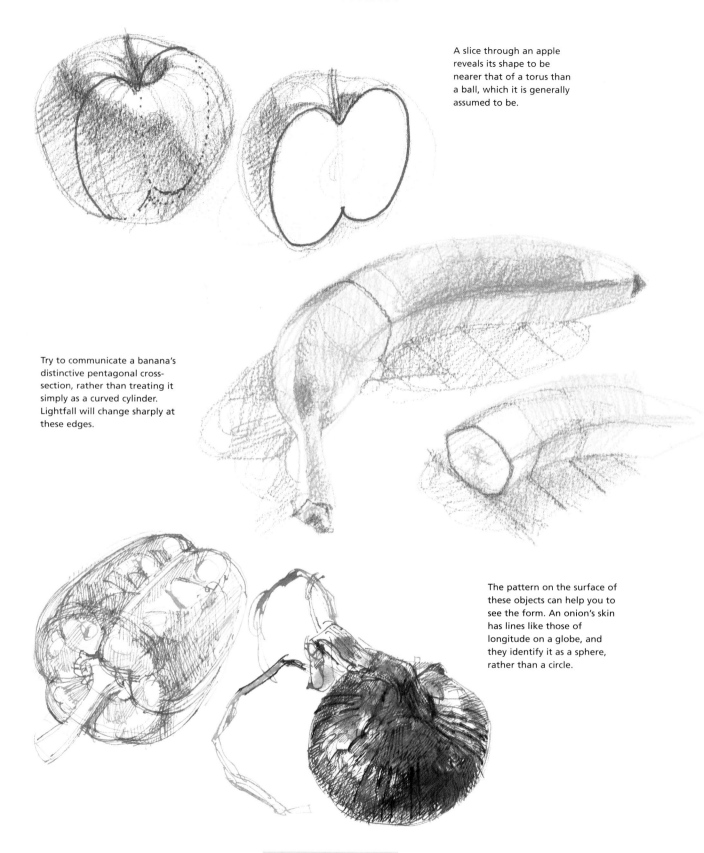

A slice through an apple reveals its shape to be nearer that of a torus than a ball, which it is generally assumed to be.

Try to communicate a banana's distinctive pentagonal cross-section, rather than treating it simply as a curved cylinder. Lightfall will change sharply at these edges.

The pattern on the surface of these objects can help you to see the form. An onion's skin has lines like those of longitude on a globe, and they identify it as a sphere, rather than a circle.

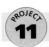

SIMPLE VOLUME

*A*SK YOUR model to curl up into a simple, compact shape with no arms or legs protruding, the sort of shape that could be carved without much waste from a single block of stone or wood. This may appear to be a repeat of project 2. In some ways it is, but this time the emphasis will be on achieving a strong impression of solidity by whatever means will make it most clear.

Methods that you used when you were describing and representing the forms of fruit and vegetables in the last project are equally applicable here. The lines on the onion that followed the spherical form of the vegetable are the equivalent of the lines of folds that wrap round the forms of a figure. Imaginary lines that were used to track around the form of the apple and the pepper can be used in just the same way to give information about the volume of a human form.

Your three-dimensional vision enables you to see solidity that may not be fully revealed by merely copying the existing pattern of light and shade, so feel free to invent tone if by doing so you can make the representation of volume clearer. Don't be afraid to draw lines, not just as outlines, but also across forms as contours or as though they were strings tied around and following the forms.

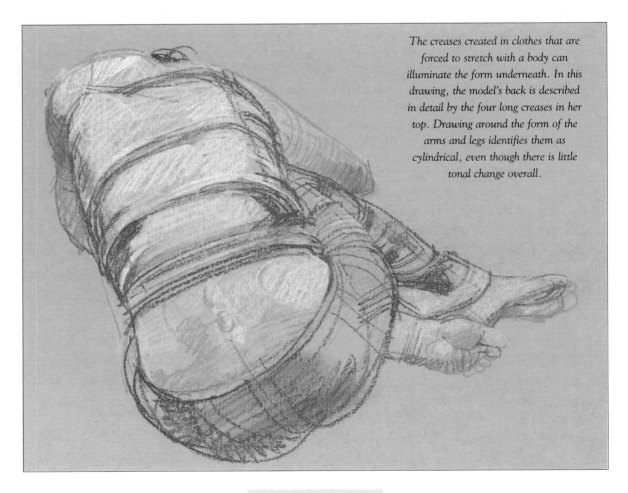

The creases created in clothes that are forced to stretch with a body can illuminate the form underneath. In this drawing, the model's back is described in detail by the four long creases in her top. Drawing around the form of the arms and legs identifies them as cylindrical, even though there is little tonal change overall.

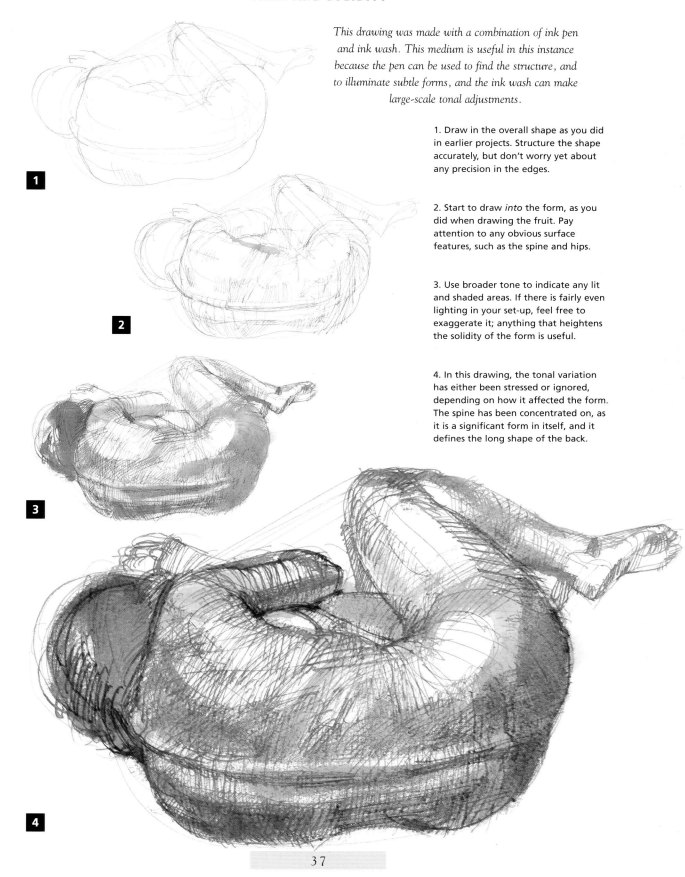

This drawing was made with a combination of ink pen and ink wash. This medium is useful in this instance because the pen can be used to find the structure, and to illuminate subtle forms, and the ink wash can make large-scale tonal adjustments.

1. Draw in the overall shape as you did in earlier projects. Structure the shape accurately, but don't worry yet about any precision in the edges.

2. Start to draw *into* the form, as you did when drawing the fruit. Pay attention to any obvious surface features, such as the spine and hips.

3. Use broader tone to indicate any lit and shaded areas. If there is fairly even lighting in your set-up, feel free to exaggerate it; anything that heightens the solidity of the form is useful.

4. In this drawing, the tonal variation has either been stressed or ignored, depending on how it affected the form. The spine has been concentrated on, as it is a significant form in itself, and it defines the long shape of the back.

COMPLEX VOLUMES

*A*FTER THE closed-up, simple form shown in the last project, this time try a much more extended pose. The aim should be the same: to search out, above all else, the solidity of the forms before you. Use any marks to do this, but don't rely on merely copying the existing light and shade – it may be enough to tell the story, but the idea here is to look for stronger, more positive expressive means.

The precise choice of pose is not important, as long as it differs from the previous very compact one. The fact that we have chosen a recumbent pose to demonstrate here is not relevant either; a sitting or standing pose will do just as well. It is your attitude that is most important, your single-minded search for form.

It is a good idea to keep to a monochromatic medium for these exercises, in order to avoid deflection of your attention from the form

This drawing was made in five minutes, after spending nearly an hour (with rests) on the step-by-step drawings shown on the right. As is often the case, having 'learnt' the form, a much stronger, more direct drawing can be made.

(notwithstanding the fact that we went into glorious colour for the fruit and vegetables!).

Remember that imparting information is one of the main reasons for making a drawing, and although the type and level of information that you pass on will vary, it should always be as clear as you can make it. A muddled, unselective drawing is almost always a bad one.

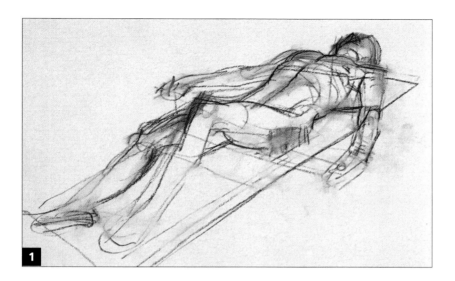

A lying pose is good here, as it forces the body to open out, and gravity collapses the form over the skeleton within, making its complex shapes evident. Use any medium you choose; we have returned to the evergreen charcoal, taking advantage of its adjustability and variety of marks.

1. To begin with, organize the structure. Even at this stage, draw through the form; don't concentrate just on the outlines.

2. Emphasize any shapes you see emerging in your drawing, even if they are unfamiliar to you. Here, the torso is virtually split into two areas, of abdomen and chest, by the rise of the ribcage.

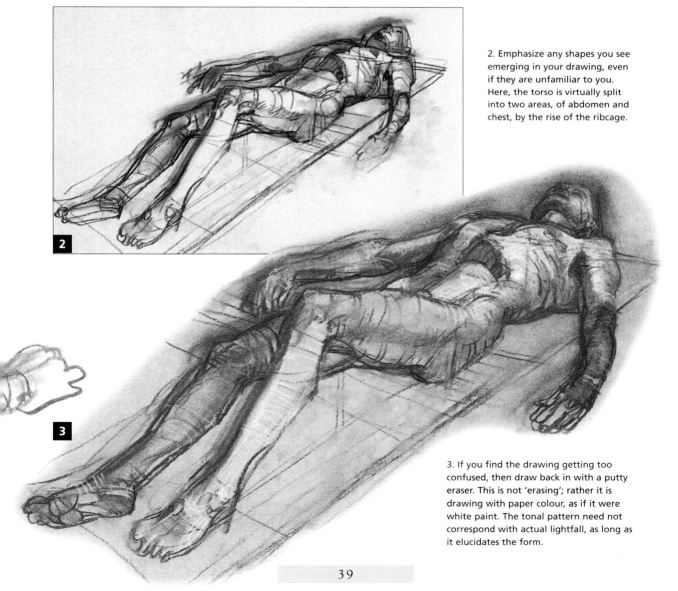

3. If you find the drawing getting too confused, then draw back in with a putty eraser. This is not 'erasing'; rather it is drawing with paper colour, as if it were white paint. The tonal pattern need not correspond with actual lightfall, as long as it elucidates the form.

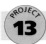

TONAL VOLUME

*W*HEN YOU make a line drawing, you are drawing edges that do not actually exist. Visually the division between, for instance, a figure and the background is simply a difference of tone, or colour. It is just generally accepted that a line can represent the point where the surface of an object turns away and out of your field of vision.

For this project you will observe only the tonal values of your subject. It usually helps if you spend a little time looking at it with your eyes virtually closed. This will present you with a monochromatic and, therefore, tonal view, and will blur your focus allowing you to see the tonal values respective to one another, without the disruptive intrusion of detail. If there are white walls in view it might be surprising how dark they appear if they are not directly lit, given that you know them to be painted brilliant white.

We have used paint; if you are happy with paint, then use it as well. If not, willow charcoal would be a good medium, as if it is used broadly on its side, it does not force lines on you. It doesn't matter which kind of paint you use as long as you use an opaque white, rather than relying on the white of the paper for the lighter colours. This will allow you to go back and re-evaluate the tones in your drawing.

Your subject can be virtually anything, but when setting up, try to observe the broad tonal values, and the pattern that they make. Rather like looking at a blurred black and white photograph, only a very small variation is required to make complex forms clear. If you have a computer with a graphics program, this would be a good place to experiment with lowering the resolution of some photographs to see quite how much blurring you can use, while still being able to understand the detail.

Look at your subject through half-closed eyes to determine the variety of tones in view. If you are unsure about the value of some aspect, then compare it to the lightest or the darkest tone in view, and decide which it is closest to. Then lay down the tones as broadly as you can, treating similar ones as actually the same; it may help if you pre-mix two or three gradations of colour, and use just those to begin with. It can be surprising how few edges and how little complexity is required for the drawing to be understandable.

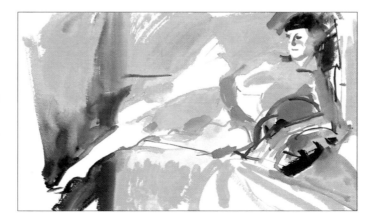

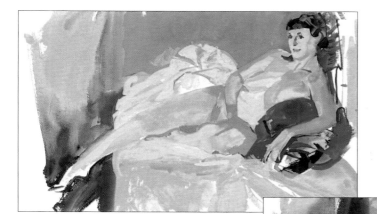

As you add detail, constantly re-check the tones against one another. It is probable that pure white will never actually appear, even in things that you know to be white, such as the sheets and wall here. Only in the sharpest highlights will you see the lightest colour.

Don't be inclined to draw lines for edges just because you know they happen to be there. In this drawing, the tones of the model's right shoulder and the background behind her, or of her left leg and the sheets, are similar, but a division between them will be understood, just as you visually understand a monochromatic photograph.

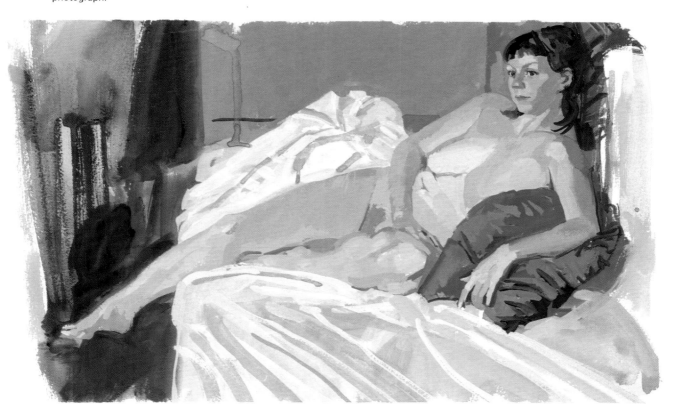

Anatomy — The Structure Within

THE SKELETON

THIS AND the following projects are intended to help you to gain an understanding of the anatomical structure of the human body, not just by looking at anatomical diagrams, but by actually working out and drawing the bones and muscles yourself. The task in this project is to add the main structures of the skeleton to some of the drawings from the standing figure project. You could use photographs of figures as your basis: pictures of athletes or dancers where you can see the bones clearly, or classical sculptures, viewed in the round or as photographs, are ideal.

The first points to identify are the places where ends of bones come close to the skin surface. Even in quite well-covered individuals these points tend not to be overlaid with fat, in extreme cases appearing as dimples instead of protuberances. We have noted these in previous projects but, to remind you, they are marked in red on the drawings here.

When you have found these salient points, refer to our drawings and sketch in the directions of the spinal column, the long bones of the limbs and the general shape of the pelvis and rib cage. In a back view, add the shoulder blades (scapulae).

It is not necessary to describe the precise shape of the bones, beautifully functional though they are; only where they directly affect the surface form do we need to know their form in any detail.

Here are contrasting examples of the positioning of bones in the body. In the foot they are all close to the surface and can be seen and felt quite easily. In the case of the back, only bony extensions from the spine actually approach the surface, the main vertebral column lying much deeper in the body.

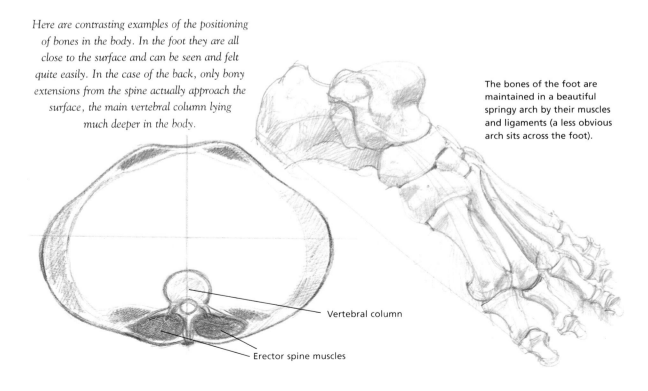

The bones of the foot are maintained in a beautiful springy arch by their muscles and ligaments (a less obvious arch sits across the foot).

Vertebral column

Erector spine muscles

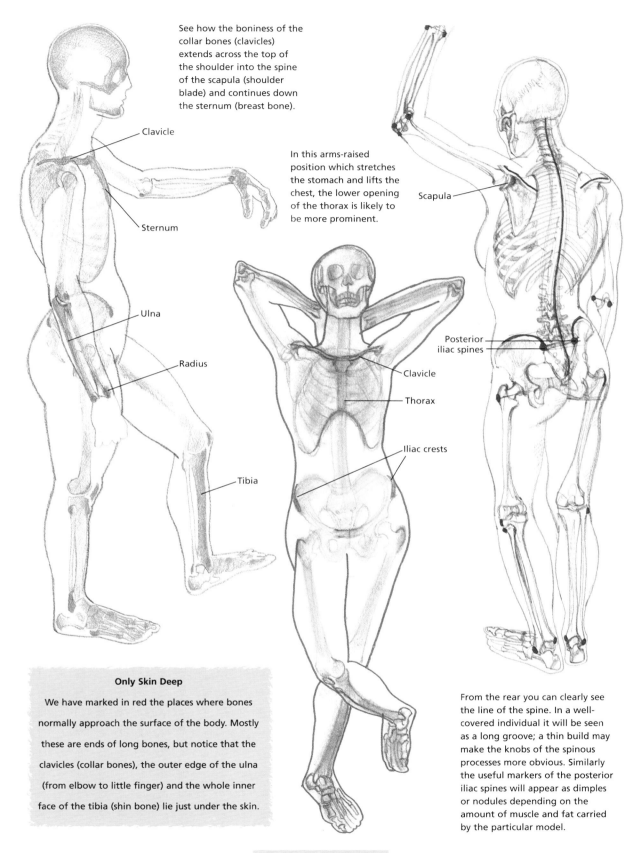

See how the boniness of the collar bones (clavicles) extends across the top of the shoulder into the spine of the scapula (shoulder blade) and continues down the sternum (breast bone).

In this arms-raised position which stretches the stomach and lifts the chest, the lower opening of the thorax is likely to be more prominent.

Clavicle

Sternum

Ulna

Radius

Tibia

Scapula

Clavicle

Thorax

Iliac crests

Posterior iliac spines

Only Skin Deep

We have marked in red the places where bones normally approach the surface of the body. Mostly these are ends of long bones, but notice that the clavicles (collar bones), the outer edge of the ulna (from elbow to little finger) and the whole inner face of the tibia (shin bone) lie just under the skin.

From the rear you can clearly see the line of the spine. In a well-covered individual it will be seen as a long groove; a thin build may make the knobs of the spinous processes more obvious. Similarly the useful markers of the posterior iliac spines will appear as dimples or nodules depending on the amount of muscle and fat carried by the particular model.

43

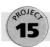

THE MUSCLES

SING TRACINGS of the figures from the last project, and with reference to the drawings below and opposite, add the main forms of the big muscle groups.

The superficial muscle layers do not account for *all* the cladding on the bony skeleton; there are sometimes two layers of muscle below these. Study of these is beyond the remit of this book, but as long as you impart lifelike form to the top layer, you can do without understanding all the deeper layers.

Then, of course, there are the internal organs. Some of these are contained within the protective cage of the thorax and so do not directly affect the surface form, but the rest are in a sort of elastic sack sitting in the bowl of the pelvis and held in place by relatively thin and expandable layers of muscle and

fascia. Try to give the muscles volume as well as shape, noting where several muscles combine to make one form. The rounded shape of the front of the thigh is a good example of this; known as the quadriceps extensor, it is a combination of three muscles with visibly separate edges (and one deep one, not visible at the surface).

Muscles exert force by becoming shorter and therefore fatter and when not working may be stretched out to assume a thinner shape than when tensed, so be alert for such changes.

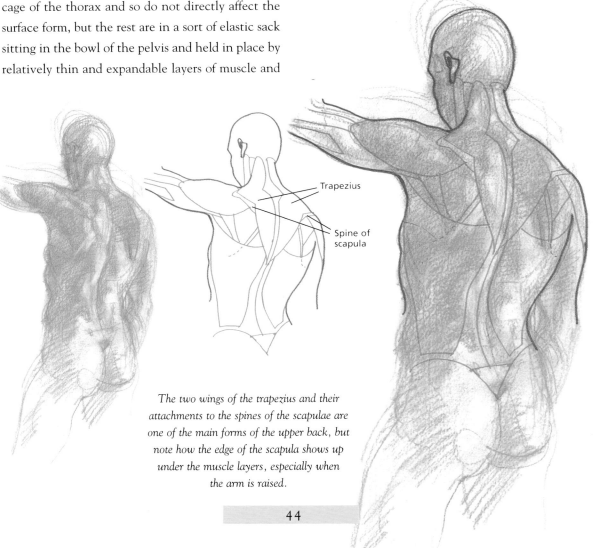

Trapezius

Spine of scapula

The two wings of the trapezius and their attachments to the spines of the scapulae are one of the main forms of the upper back, but note how the edge of the scapula shows up under the muscle layers, especially when the arm is raised.

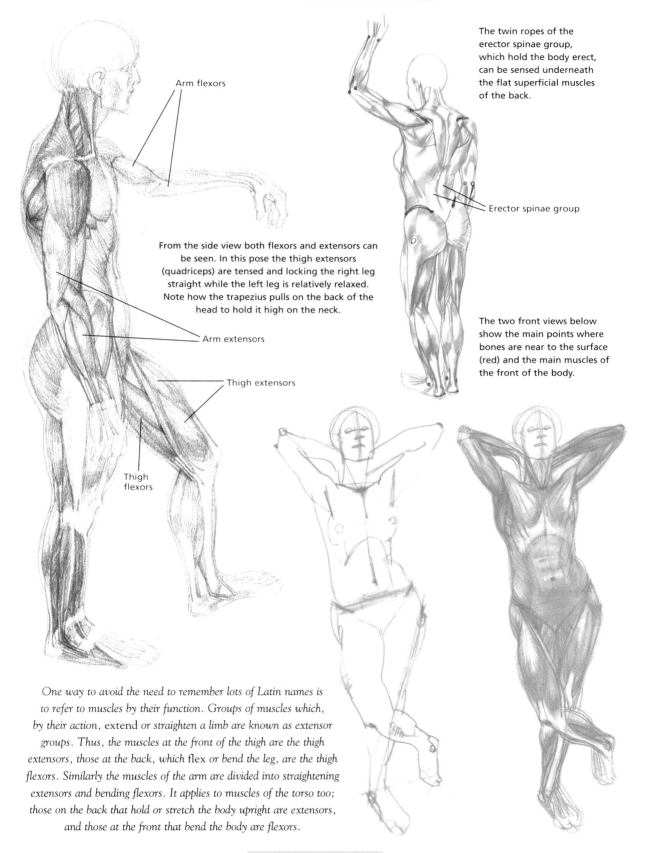

Arm flexors

The twin ropes of the erector spinae group, which hold the body erect, can be sensed underneath the flat superficial muscles of the back.

Erector spinae group

From the side view both flexors and extensors can be seen. In this pose the thigh extensors (quadriceps) are tensed and locking the right leg straight while the left leg is relatively relaxed. Note how the trapezius pulls on the back of the head to hold it high on the neck.

Arm extensors

Thigh extensors

The two front views below show the main points where bones are near to the surface (red) and the main muscles of the front of the body.

Thigh flexors

One way to avoid the need to remember lots of Latin names is to refer to muscles by their function. Groups of muscles which, by their action, extend or straighten a limb are known as extensor groups. Thus, the muscles at the front of the thigh are the thigh extensors, those at the back, which flex or bend the leg, are the thigh flexors. Similarly the muscles of the arm are divided into straightening extensors and bending flexors. It applies to muscles of the torso too; those on the back that hold or stretch the body upright are extensors, and those at the front that bend the body are flexors.

45

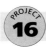

HANDS AND FEET

*T*HE SURFACE anatomy of hands and feet is dominated by their bones and tendons. On the back of the hand these tendons are extensions of muscles in the lower arm which pull on the bones to open the hand (extension). In action, they are easily seen and felt. Similarly, tendons from the lower leg figure prominently on the top of the foot when it is pulled upwards. The tendons which perform the contrary action, flexion, by which the toes and foot are pointed and pulled down, are hidden under thick pads of tissue on the sole of the foot, which also hide the only muscles of any size, those that retain the arch and springiness

of the foot. The same tendons of flexion are covered by similar but rather less thick pads on the palm of the hand but there are two prominent muscles that can be seen and felt – a large one on the thumb side of the palm and a second smaller one beneath the little finger.

Draw your own hands and feet, looking and feeling with your fingers for the bones and tendons and distinguishing them from the veins. By flexing, extending and twisting them, you will be able to make the forms near to the surface more apparent. The prominent bones at the wrist and ankle are the ends of the long bones of the lower arm and leg respectively.

There are only two muscles with any shape on the palm of the hand, the thumb flexor and the little finger flexor.

There are virtually no muscles on the back of the hand, the most prominent features being tendons by which the muscles of the forearm pull on the fingers.

The dotted lines show flexed tendons over which snake veins in a pattern which is different in every individual.

The padded look of the rest of the palm is due to just that – padding.

46

Hands and feet are similar in this respect: they have only bones, veins and tendons on their extensor surfaces – the back of the hand, the top of the foot. On the sole of the foot, as on the palm of the hand, there are several layers of strong muscles which retain the arch of the foot and provide its remarkable springiness, but they lie under the prominent forms of padded tissue.

1

2

3

1. Roughly sketch in the general shape of your own thumb, hand and fingers.

2. By observation *and* feel, the main joints of the thumb can be indicated and by moving the thumb you will be able to identify the extensor tendons.

3. Delineate the small muscle that you can feel between the thumb and the first finger and the part of the thumb flexor that can be seen from the side view.

Tendons of the calf muscles run under strong fibrous bands (not drawn) to retain them at the ankle, and thence to the bones of the toes and heel.

The powerful Achilles tendon attaches the calf flexors to the heel. See how some tendons use the ankle bones as pulleys to change direction.

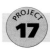

THE HEAD

*T*HE OUTER form of the human head and face is largely dictated by the bony shell of the cranium and lower jaw bone. There are two strong muscle groups, the masseter and the temporalis that activate the lower jaw and they fill out what would otherwise be hollows. Most of the other muscles are relatively thin and although their effects are seen in a multiplicity of facial expressions, their individual shapes are not evident superficially and you need not bother with their names and details.

We suggest for this project that you draw your own face in the mirror, feeling for the underlying bone with your fingertips. Press quite hard and try to grasp the cheek bone (zygomatic bone) between finger and thumb and try to visualize its shape and add that information to what you can see in the mirror. Run a finger under your lips around the dental arches and sense their width and curvature.

By biting hard, the masseter muscle will be easily felt and by tensing other facial muscles (by grimacing!), you will be able to feel the edges of some of the other main muscle groups. Leave out head hair, eyebrows and any other facial hair and, for the rest, utilize the information in the drawings.

Once having, literally, felt the essential forms in this way and delineated them, you will ever afterwards look for them in the faces that you draw.

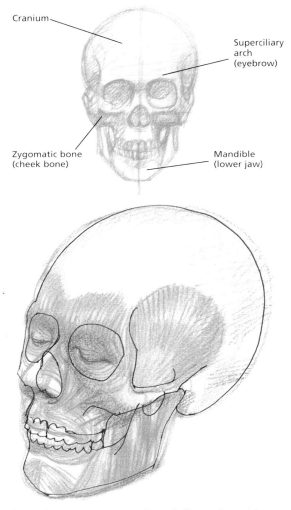

Cranium

Superciliary arch (eyebrow)

Zygomatic bone (cheek bone)

Mandible (lower jaw)

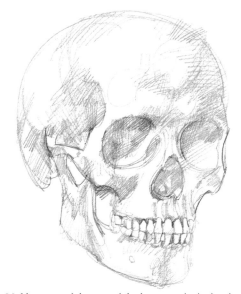

Unlike most of the rest of the bones in the body, the skull is close in shape to the superficial form of face and head that we see in life.

It is only necessary to insert the eyeballs into their sockets, add the cartilage forming part of the nose and fill in the shallow hollows with muscle and a recognizable face emerges.

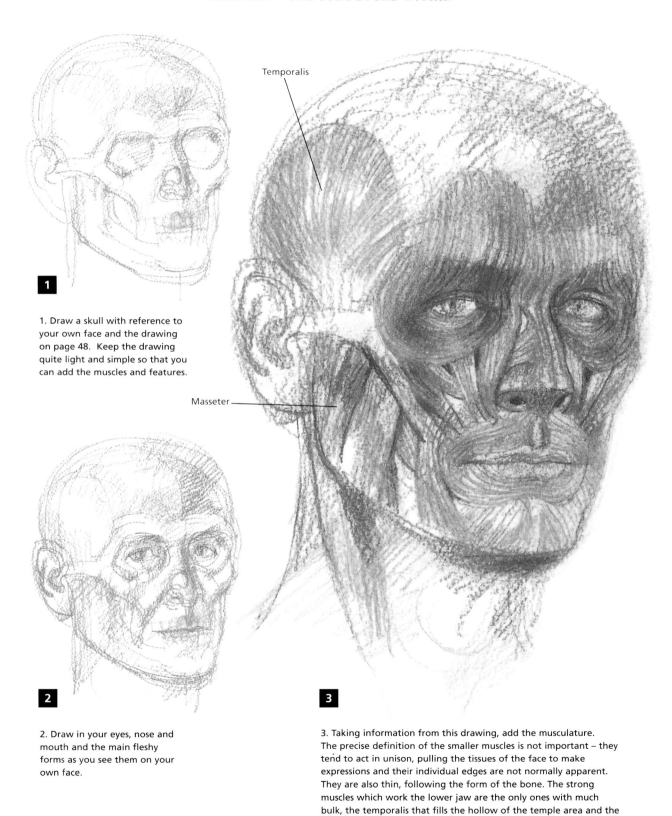

Temporalis

1

1. Draw a skull with reference to your own face and the drawing on page 48. Keep the drawing quite light and simple so that you can add the muscles and features.

Masseter

2

2. Draw in your eyes, nose and mouth and the main fleshy forms as you see them on your own face.

3

3. Taking information from this drawing, add the musculature. The precise definition of the smaller muscles is not important – they tend to act in unison, pulling the tissues of the face to make expressions and their individual edges are not normally apparent. They are also thin, following the form of the bone. The strong muscles which work the lower jaw are the only ones with much bulk, the temporalis that fills the hollow of the temple area and the masseter that joins the cheek bone to the lower jaw or mandible.

MORE DIFFICULT POSES

*Y*OU MAY prefer not to attempt this rather difficult exercise or to leave it until later – as we have said before, the exercises can be undertaken in any order.

If you do decide to try it, you will need to choose some poses from those that you have already drawn or draw some especially for the exercise. Look for poses in which limbs or torso are foreshortened, in which the flexible and jointed internal skeleton is pulled into positions unlike the 'normal' views featured in the upright anatomy diagrams.

Your own arm or leg viewed end on in the mirror will provide a good, testing subject for anatomical study and you can feel for the bones and ligaments as you did for the hands and feet. Twisted and hunched poses are good too, as are positions in which one or more of the main muscle groups are strongly flexed.

If you find that working out the shape and location of every muscle and near-the-surface bone is really too difficult, don't worry too much – just put in the ones that seem right. You will sometimes be surprised by how close together some salient points appear that are normally far apart, a fact which will in turn make some muscles look impossibly short. But have the courage to believe in and put down what you see. We will look at this again in more detail in projects 30–33.

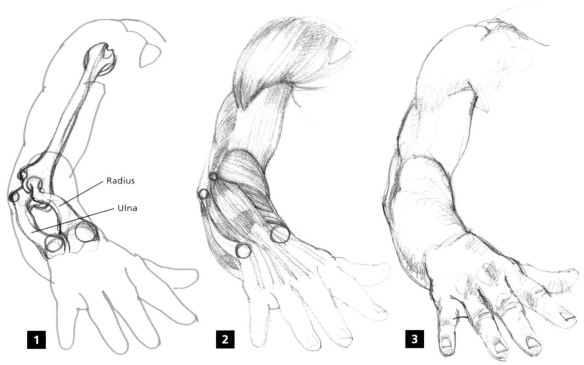

1. In this view the bones of the forearm look impossibly short and thick, but this, of course, is in the nature of foreshortening: long objects viewed from one end appear to be short.

2. The same applies to the long muscles of the forearm – those that stretch from elbow to wrist must be accommodated between those points even though they are now rather close together.

3. In life, your brain compensates for the fact that the objective width of the lower arm is much the same as its length, and sees it as an arm of normal length.

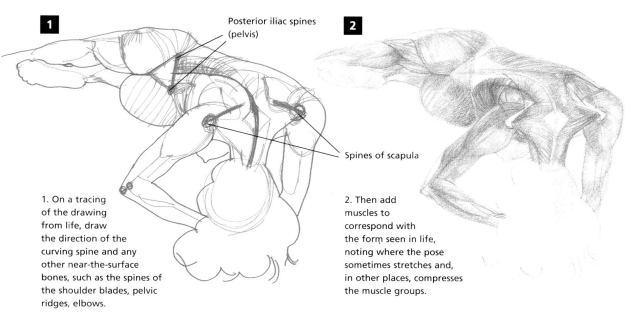

1

Posterior iliac spines
(pelvis)

2

Spines of scapula

1. On a tracing
of the drawing
from life, draw
the direction of the
curving spine and any
other near-the-surface
bones, such as the spines of
the shoulder blades, pelvic
ridges, elbows.

2. Then add
muscles to
correspond with
the form seen in life,
noting where the pose
sometimes stretches and,
in other places, compresses
the muscle groups.

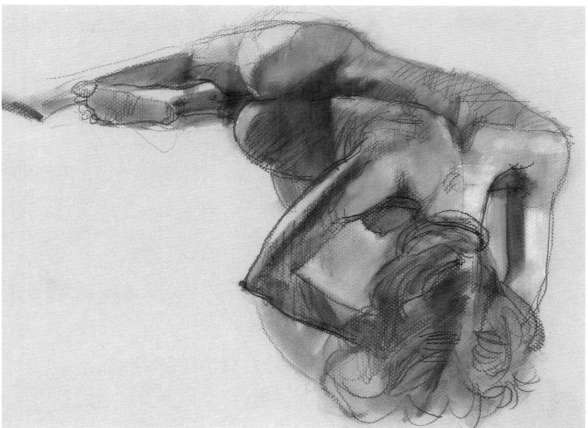

We chose this drawing as a more difficult one to anatomize as it involves foreshortening and an extreme degree of twist between pelvic and shoulder girdles. Don't be depressed if you find it too difficult to work out where all the muscles go – it really needs more anatomical knowledge than we are able to pass on to you here. Just try to identify the main structures of the body, the pelvis, the backbone and the shoulders.

Dynamics

In reality, the human figure is a dynamic structure. In doing anything, even lying down, our bodies are expressing and adjusting to a variety of physical forces. The tension, applied by our muscles; the subsequent compression, resisted by our bones; the blanket of gravity, ever trying to make puddles of all of us, but which is foiled to varying degrees by our muscles and bones, their connective tissue, our fat deposits and our skin, which neatly contains the lot.

This section is mainly concerned with how these stresses evidence themselves in the surface of the body, and in any surfaces in contact with the body. Investigations into the stressed figure are among the most interesting and rewarding – for the artist. You might find professional models instinctively adopting rather gymnastic poses: this is because they will have been asked to do so by art students many, many times before.

It might seem confusingly abstract to try to draw 'stresses'. After all, you cannot see them, and haven't we been emphasizing that you should believe your eyes only? Well, yes, but good drawing is fundamentally about editing; about finding out what is important about your subject, selecting it, and de-emphasizing or discarding what is unimportant. The selections you make are entirely personal; but in these cases, it will be the location, direction, and kind of stresses that characterize the pose which need to be found.

Balance and Weight

BENDING

E HAVE already looked at how the body contrives to balance on the small platform provided by the feet, and how in an upright relaxed posture, the head is almost always positioned vertically above the foot that is bearing the weight.

In this section we will look at how the body adapts to balancing in less upright poses, some of them shifting the centre of gravity away from the vertical line through the head. When posing your model, ask for the most extreme weight shifts that can be managed, including bending backwards or forwards from the waist, but remember that such poses can be very difficult to hold for long periods. So have pity, draw as quickly as you can and let the model have frequent rests.

As soon as you can, establish the centre of gravity by drawing a vertical line through the weight-taking ankles and pay particular attention to where it divides the body that is balanced above them. The weight distribution about this line will not be the same in all models: a more bulky upper body will pull the centre of gravity towards it and larger hips and thighs will move it the other way.

The ballet position known as the *arabesque,* in which one leg is stretched out backwards parallel to the ground and the torso is bent forward from the hips, is a splendid example of standing balance, in which the centre of gravity has shifted down the body just about as far as it is possible to go without falling over.

Unlike the balanced standing poses in project 9, where the torso is relaxed and the head sits directly above the weight-taking heel, these two drawings show how the vertical line through the head shifts to one side when the torso is bent strongly sideways by muscular action.

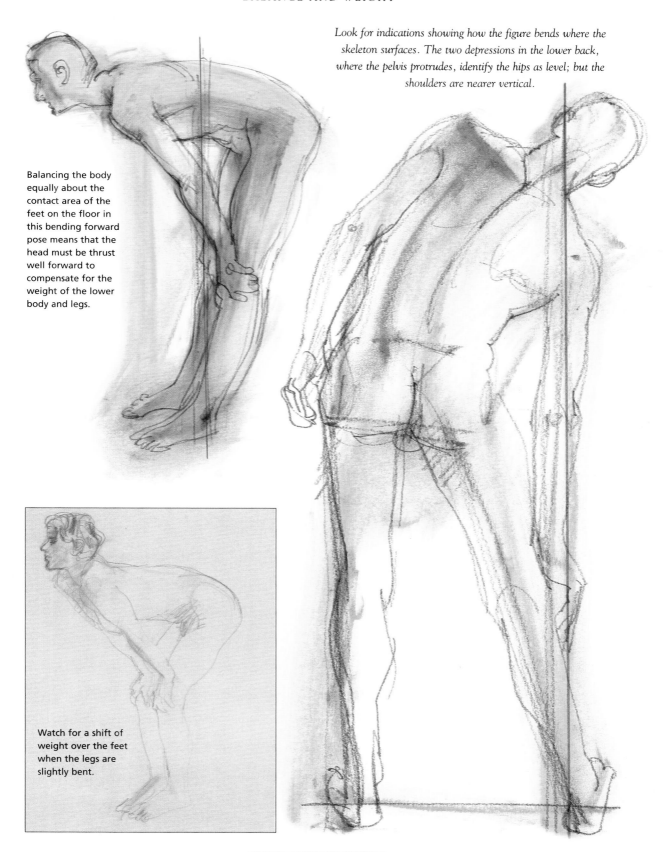

Look for indications showing how the figure bends where the skeleton surfaces. The two depressions in the lower back, where the pelvis protrudes, identify the hips as level; but the shoulders are nearer vertical.

Balancing the body equally about the contact area of the feet on the floor in this bending forward pose means that the head must be thrust well forward to compensate for the weight of the lower body and legs.

Watch for a shift of weight over the feet when the legs are slightly bent.

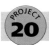

FABRIC STUDIES

20

*I*N EARLIER projects we touched on the way that cloth falls in response to the pull of gravity and how, as clothing, it is restricted and moulded by the figure it covers.

At some stage, and now is as good a time as any, it is a good idea to make some studies of cloth or clothing hanging over a chair or some other similar inanimate object. This will allow you to make detailed studies, taking as much time as you like, without encountering the problems of the model's movement during posing and even greater disruptions at each rest period.

Set up the fabric so that there is a certain amount of tension over the underlying support, some free fall and sweep, and also some folding of the fabric on itself, where it meets the floor, for example. Your aim should be to work out just what is happening to the cloth, where the folds show stretching and tension, and the different type of folds that result from collapse of the fabric. Note carefully where folds are soft and curved and where they are sharp and angular. All fabrics have their own characteristic fold patterns that reflect the nature of the material: heavy wools and velvets fold in a quite different, generally softer, way than do fabrics such as crisp cottons and taffeta.

Try to be analytical above all. If you honestly set out to learn as much as you can, you will find that, almost by accident, the drawing becomes descriptive and even beautiful.

1. Begin by finding and drawing the main shapes that the fabric makes as it falls, and, just as you would if this was a figure sitting down, establish the form of the chair as well.

2. Keep in mind the lightfall and tonal values, but don't be led by them. Try to draw not just what it looks like, but what is *happening*. The fabric has weight, and the creases are caused by it finding its easiest way to the ground.

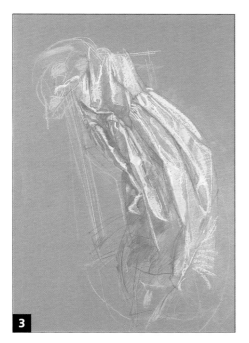

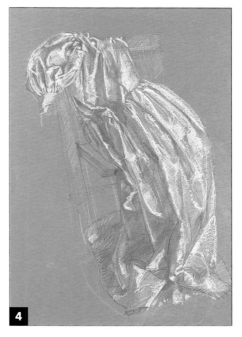

3. Notice the quantity of sharp edges that may appear as you refine your drawing. Creases are a combination of graceful curves and sharp changes of direction.

4. The long striated creases formed as the fabric descends are in direct contrast to their rucked and chaotic character where they hit the floor: this is the crux of this set-up, as it 'grounds' it in space.

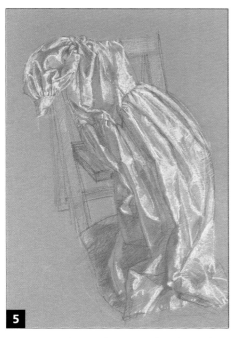

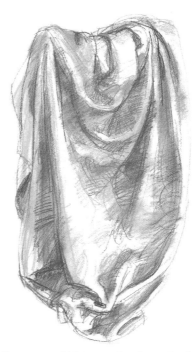

5. As you work, re-evaluate your drawing, and simplify it if it seems too complicated. It is very easy when presented with such a complex surface to become bogged down in the pattern and detail, at the expense of the overall form.

A different type of fabric, much softer and rather thicker, falls into more rounded folds with no sharp angles, but the principles of drawing it are the same.

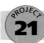

BENDING 2

\mathscr{T}HIS PROJECT is intended to explore further the balance shifts that you looked at in project 19, but this time also adding loose clothing. The clothing can be just a wrapped sheet or blanket, or it could be a dressing gown, but it must not be too tight as the point is to see how the cloth reacts to the downwards pull of gravity and the restraining effect of the body that it covers.

Wherever the cloth experiences a free fall it will, like a plumb line, indicate the true vertical, and a line parallel to it through the centre of the weight-bearing foot or feet will indicate the centre of

gravity in that bending action. It may not be immediately clear which of the feet is bearing most of the weight in these bending poses – sometimes it is evenly distributed, in which case the line of centre of gravity will meet the floor somewhere between the two feet. Watch out also for the straight pulls in the fabric that reveal the orientation of the main supporting leg. When the pull of gravity is combined with a countering stretch between two points of tension, a shoulder and an opposite ankle, for example, you will often see a wonderful sweeping swathe of cloth joining the two.

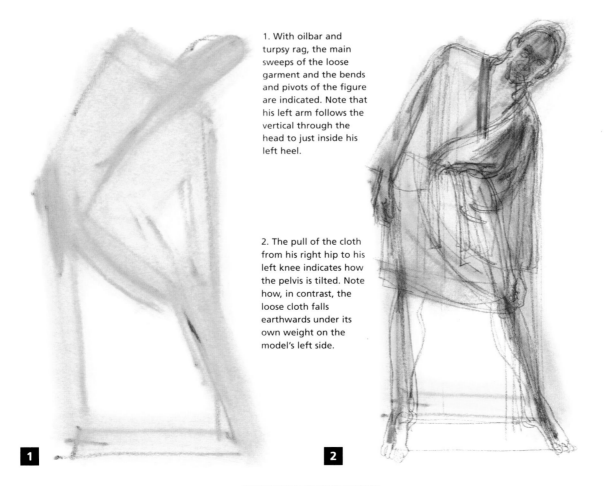

1. With oilbar and turpsy rag, the main sweeps of the loose garment and the bends and pivots of the figure are indicated. Note that his left arm follows the vertical through the head to just inside his left heel.

2. The pull of the cloth from his right hip to his left knee indicates how the pelvis is tilted. Note how, in contrast, the loose cloth falls earthwards under its own weight on the model's left side.

1

2

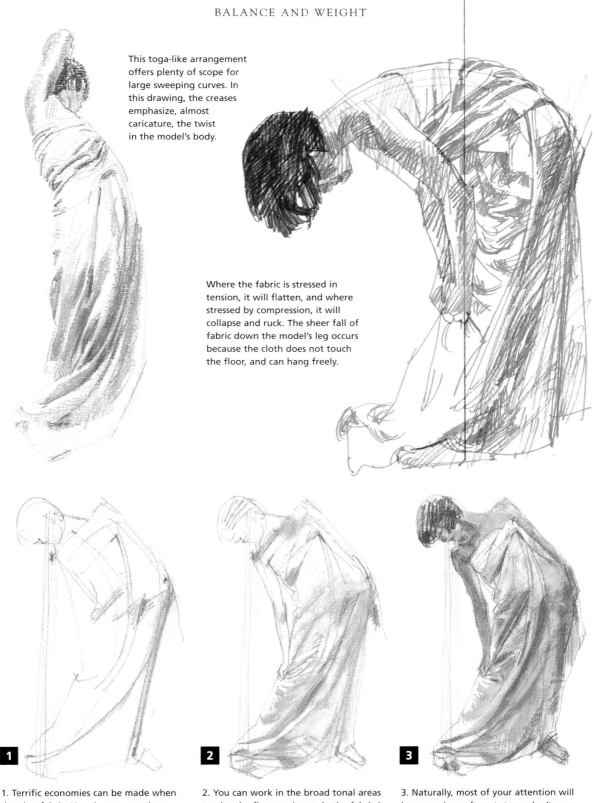

This toga-like arrangement offers plenty of scope for large sweeping curves. In this drawing, the creases emphasize, almost caricature, the twist in the model's body.

Where the fabric is stressed in tension, it will flatten, and where stressed by compression, it will collapse and ruck. The sheer fall of fabric down the model's leg occurs because the cloth does not touch the floor, and can hang freely.

1

2

3

1. Terrific economies can be made when drawing fabric. Here just two or three creases have been identified to represent the form.

2. You can work in the broad tonal areas to give the figure volume. As the fabric is stretched over the model's left leg, it reveals the form of the hip; elsewhere, it is opaque.

3. Naturally, most of your attention will be on regions of most stress; don't worry if they seem more overworked than elsewhere. It is these areas of investigation that enrich a drawing.

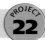

DRAPED FIGURE

*J*N THIS project you will use the tension in fabric to tell you about the form of the body beneath. You should drape the model from head to toe in the biggest light-coloured sheet you can find. She can be in virtually any pose and you should experiment to see what works best; your aim is to see the figure beneath as a simple building-like form, so uncomplicated sitting or reclining poses will work well. Experiment with lighting and try to obtain a fairly directional light as this will make the shapes that the fabric assumes clearer.

Try to resist the tendency to perceive the sheet too casually as a sort of imprecise covering; the cloth is being *dragged* down over the figure by gravity, and takes a very direct downward path until it reaches the floor or other immovable surface, when it folds back upon itself, just as you saw it do in the study of cloth on pages 56–57. In fact the overall form and proportion of the body is probably more clearly revealed than if the sheet were not there at all. If your model moves for a break and then sits down again, the creases will almost certainly be different ones but their general thrust will be very similar, and it is on these more general folds that you should focus. Even without paying much attention to the smaller wrinkles, it is surprising to see the level of detail in the form of the figure that can be sensed if the major creases in the cloth are understood.

1. As previously, look for the main directions taken by the fabric, and note any sharp changes in lightfall to begin with.

2. Here, the fabric has helped to identify the figure as three simple forms, as we saw in the earlier projects. Look for similar clues in your set-up.

3. The fabric is sheer where it falls over the body, on the shoulder and particularly over the thighs, and creased only where free.

4. Although the model moved during this pose, it does not matter; as long as you understand the nature of the fabric, you do not have to draw each crease.

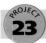

ON A HARD SURFACE

*I*N A STANDING pose, as we have seen, the figure resists the unbalancing pull of gravity by adjustment of the body weight over the feet. Rather less obviously, the body tissues themselves are also subject to, and shaped by, the same downward pull.

If you ask your model to adopt a pose lying down on one side on a fairly firm surface, its effect will be much more clearly visible. Relatively soft tissue will now be pulled across the body by gravity, the rigid structure of the pelvis will be pushed upwards and the semi-rigid shoulder girdle on the down side will compress as much as it can, but not enough to prevent the neck being pulled downward by the weight of the head. The whole contact area of the body with the hard support surface will be as flat as it can be, pushing all fleshy curvature to the other, upper, side of the body.

Above all, try to reveal in your drawing all the evidence of the pull of gravity that you can identify. If you turn your drawing through ninety degrees so that you are viewing the figure in the upright mode (probably sitting, as legs are usually bent to maintain a sideways recumbent position), it should look wrong, the head and soft tissues seemingly pulled sideways as though pinned to a wall.

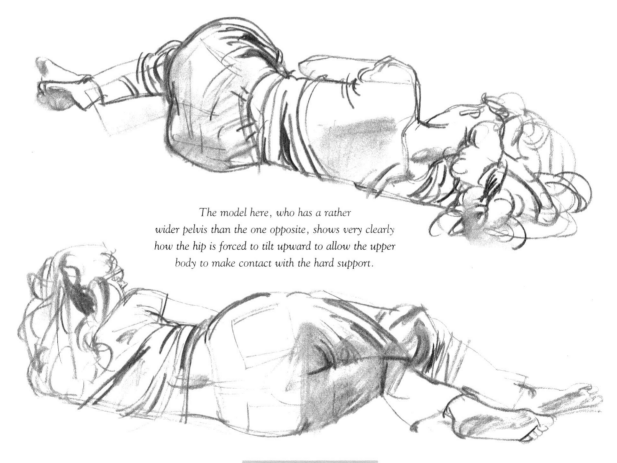

The model here, who has a rather wider pelvis than the one opposite, shows very clearly how the hip is forced to tilt upward to allow the upper body to make contact with the hard support.

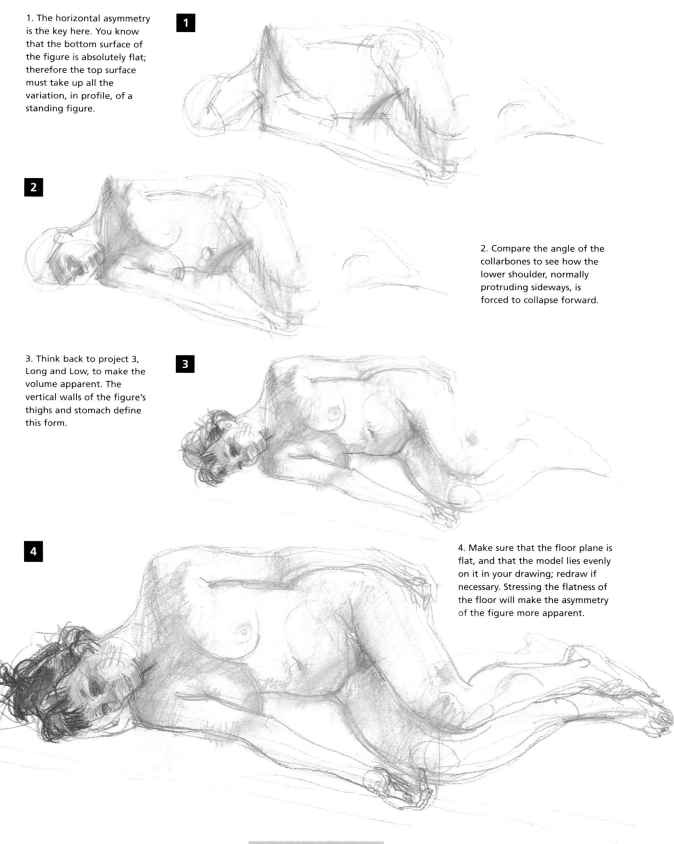

1. The horizontal asymmetry is the key here. You know that the bottom surface of the figure is absolutely flat; therefore the top surface must take up all the variation, in profile, of a standing figure.

2. Compare the angle of the collarbones to see how the lower shoulder, normally protruding sideways, is forced to collapse forward.

3. Think back to project 3, Long and Low, to make the volume apparent. The vertical walls of the figure's thighs and stomach define this form.

4. Make sure that the floor plane is flat, and that the model lies evenly on it in your drawing; redraw if necessary. Stressing the flatness of the floor will make the asymmetry of the figure more apparent.

24 RECLINING FIGURE ON A SOFT SURFACE

*I*N THIS project the emphasis is still on the interaction between the figure and the support, but now the roles have been reversed. This time pose the model on a soft surface that will yield to the form of the figure – a soft settee, some large cushions, even a beanbag – anything that will give underneath your model (who is likely to thank you for the comfort). The focus of this arrangement is that instead of flattening out and 'giving' to a hard surface, like a floor, the form retains its shape and appears partially lost in the support.

Your aim is to show that the figure is actually buried inside the support, which emerges in front of it; it is important to stress that the line which you see dividing the figure from the surface is not the edge of the figure, but the edge of the surface. It is a good idea when you are drawing a figure in a pose

like this to imagine the shape of the indentation that is created in the surface. If you imagine, and perhaps even actually draw, the edges which are hidden from your view, it can be easier to make sense of the total figure, and also to see just how much is obscured. The tendency otherwise can be to try to compensate for the missing parts by exaggerating the proportions of what you can see, which will result in a figure which seems to float uneasily above the surface.

A line has been superimposed over this drawing describing the amount that is obscured by the supporting cushions. It can help if you draw this line yourself, so that you do not overstate the parts that you can see.

This figure has sunk into the settee to the extent that she is only visible fully above the hips. The edge of the cushion below her right thigh emerges in front of her leg, and it is this which makes sense of the pose.

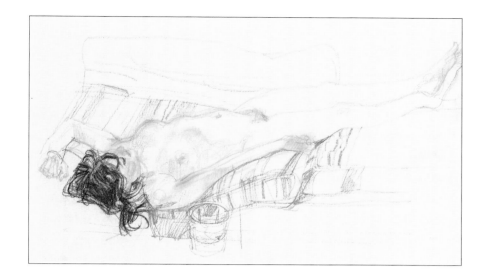

This time, it is the figure which emerges from the mattress. The line defining her arm begins as a description of her shoulder, and ends at the edge of the mattress where it turns away from our vision and down to her hand.

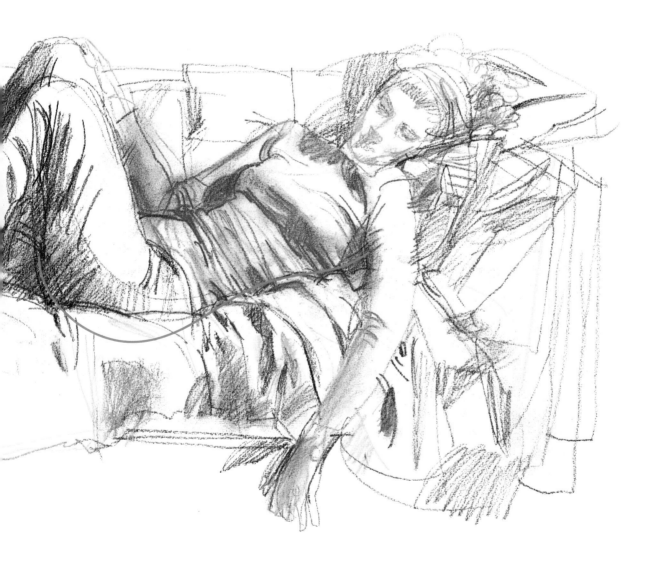

Tension and Relaxation

TENSION

PROJECT 25

*T*HE NEXT five projects are concerned with the expression of stress and tension in drawing and the opposite quality of loose relaxation – the dynamics of the figure, clothed and unclothed.

In earlier projects you will have encountered these characteristics in supporting and non-supporting limbs and also in stretched and loosely falling cloth. For this project we want you to look at poses in which the body is supported in more extreme ways requiring greater muscular activity and tension. Inevitably such poses will be hard for the model to hold for more than a few minutes, so you will have to work quickly and in short spells. Concentrate on the areas where you see the greatest stress and work outwards towards the areas of least stress. You will probably need to return time and again to the main centres of tension to reinforce and modify them, and this may very well mean that these areas appear more worked on, thereby further emphasizing them. This is the right way to achieve emphasis, not artfully but naturally, the close searching lines and strong tones showing where your attention has been centred.

As always, but especially in this type of pose, be watchful for distress in your model: if a pose is really causing discomfort or even pain, abandon it and choose another one. Or if you must have it, take a photograph as reference.

Rapid drawing is not just a practical necessity, it is a useful restriction. It forces you to edit your drawing down to the most important concerns, which makes for more economical observation.

The stresses in this dynamic pose are manifold, but it is the long quadriceps muscles of the right thigh which are most taxed in supporting the entire body weight.

66

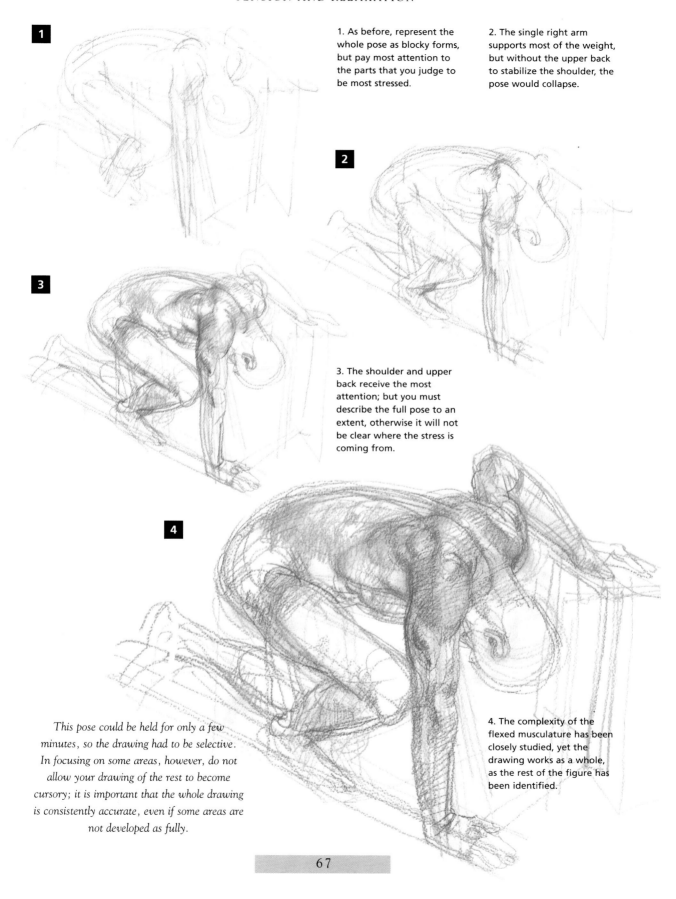

1

1. As before, represent the whole pose as blocky forms, but pay most attention to the parts that you judge to be most stressed.

2. The single right arm supports most of the weight, but without the upper back to stabilize the shoulder, the pose would collapse.

2

3

3. The shoulder and upper back receive the most attention; but you must describe the full pose to an extent, otherwise it will not be clear where the stress is coming from.

4

This pose could be held for only a few minutes, so the drawing had to be selective. In focusing on some areas, however, do not allow your drawing of the rest to become cursory; it is important that the whole drawing is consistently accurate, even if some areas are not developed as fully.

4. The complexity of the flexed musculature has been closely studied, yet the drawing works as a whole, as the rest of the figure has been identified.

RELAXATION

*I*N TOTAL contrast to the tense poses of the last project, we want you now to set up a pose that embodies complete relaxation. Perhaps this requirement can be met by a model who is flat out and fast asleep, but what we have in mind is a pose which is basically upright, but propped and supported in such a way that muscular activity is at a minimum, if not entirely absent, limbs and head relaxed and lolling.

Of course, however loose and slack the muscles are, however loosely connected are the bones of the skeleton, the individual pieces of it are still joined and rigid. The body is not a bean bag, the long bones still function as props and limit the degree of collapse in any pose. Your task is to catch the pose and to emphasize the feeling of relaxation without eliminating the underlying sense of structure. One way to do this is to let your own body participate in the action (or inaction): let your arm and wrist relax, then your line will look relaxed too. Feel the loll of the head, the slump of the torso, the splay of legs and arms. When you described tension in the last project, the chalk or charcoal was held firmly and applied with vigour; now is the time to let it float and loop softly.

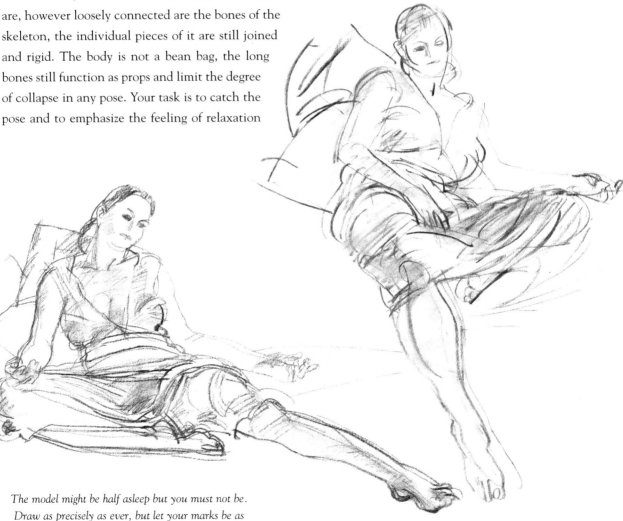

The model might be half asleep but you must not be. Draw as precisely as ever, but let your marks be as relaxed as the muscles of the figure.

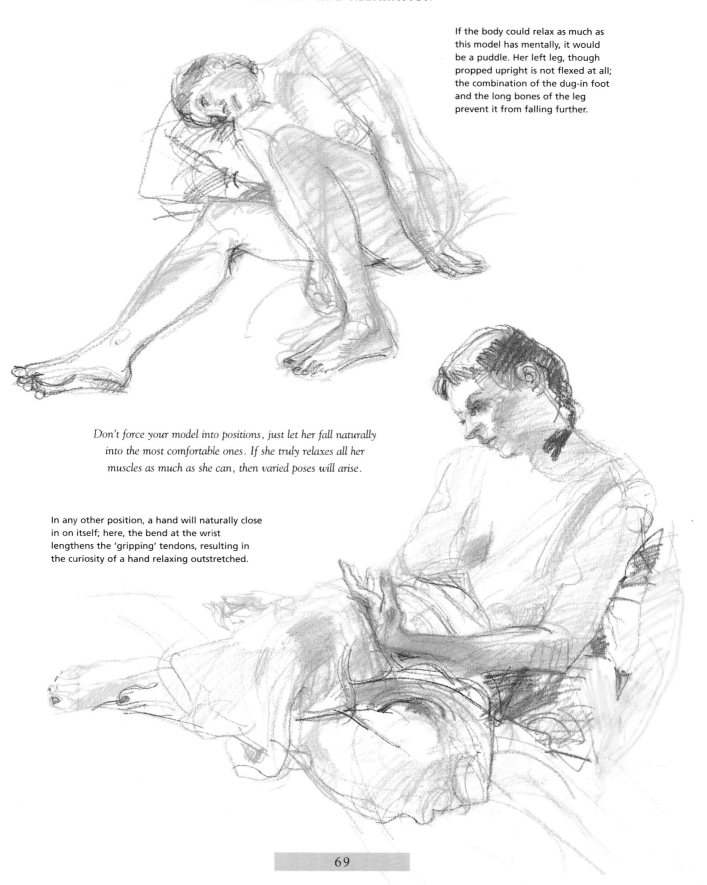

If the body could relax as much as this model has mentally, it would be a puddle. Her left leg, though propped upright is not flexed at all; the combination of the dug-in foot and the long bones of the leg prevent it from falling further.

Don't force your model into positions, just let her fall naturally into the most comfortable ones. If she truly relaxes all her muscles as much as she can, then varied poses will arise.

In any other position, a hand will naturally close in on itself; here, the bend at the wrist lengthens the 'gripping' tendons, resulting in the curiosity of a hand relaxing outstretched.

SEMI-RECLINED, CLOTHED FIGURE

*T*HE OBJECTIVE of this exercise is to observe the stresses of tension and compression that occur in clothes which are forced to accommodate the flexion and twisting of the human body. Your model should be lying or semi-reclining in a position whereby she is supporting herself on her arms, or with her knees bent; try variations of lying on the floor reading something perhaps, or any pose which creates as many folds of different kinds in her clothes.

Clothes which are fairly loose fitting are best, although not absolutely necessary, but they should not be tight and stretchy. Try to see the main shape of the folds, and their type – where fabric is stretched, the folds will be pulled tautly from the points where the body presses against the cloth, whereas where the fabric is compressed or relaxed then the cloth will fold upon itself, perpendicular to the stress, affected more by its own weight or stiffness.

A single long sag in a loose jumper can say a surprising amount about the form beneath it: in the painting on this page, the top of the crease running down her T-shirt is in tension, stretched by the fabric's weight over her shoulder, while lower down it is rucked in compression from the accumulation of cloth. The main thrust of the folds is as important, and can be drawn as simply, as the dynamic structure of the body that you looked at earlier.

An analysis of the drawing shows the main stresses in the body that the clothing describes.

1. Quickly organize the main shapes and folds of the pose. Here, paint of indiscriminate colour is used.

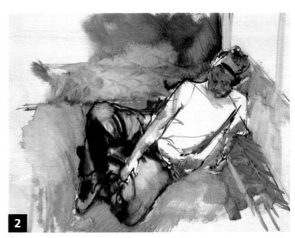

2. Use larger areas of wash to make evident the tonal variation in the subject.

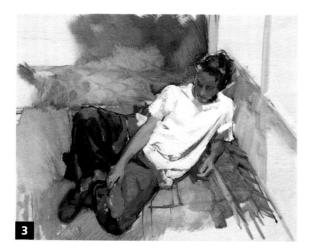

3. The definition of the clothes and the direction and form of the creases are investigated. The top edge of the figure is clearly defined as the cloth pulls across it.

4. Simplify the shapes if they have got too complex and are confusing the form. If the model has moved, you can just redraw new creases, as long as their sense is the same.

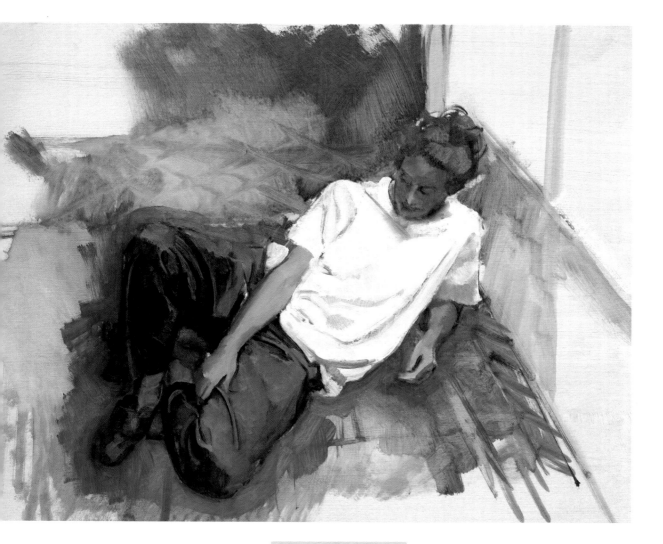

TIGHT AND LOOSE CLOTHING

*A*S CLOTHES become more close fitting, more like a series of connected tubes, they are under greater stress when responding to the bending of the limbs they enclose. Specialist sports clothes are increasingly made from elastic fabrics that resemble and behave like a second skin, but most everyday garments are not completely form-hugging and must fold and crease as the body moves. As we have seen from the studies of fabric away from the body, folds made under the same stresses, although never exactly the same, show very similar patterns and forms.

For this reason, rather than just copying the folds, you should try to discover and draw their character, their dynamics. This is practical too, as after each period of rest for the model, the folds will be different in detail when he resumes the pose but similar in their response to stretching and rucking movements caused by the figure beneath.

To get the most from this exercise, ask your model to wear several layers of clothing, perhaps in different fabrics: an outdoor coat that folds well, perhaps made of leather, left open to reveal the layers of clothing underneath, and shoes. Beginners are often wary of drawing shoes, but they are basically only feet with soles attached – pay attention to the shape of the soles and how they make contact with the ground. If you get that right, the rest falls into place.

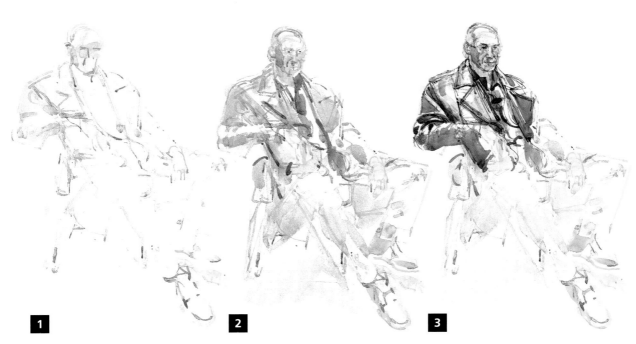

1 **2** **3**

1. Here, a combination of ink and pen is used, but if you start by drawing with a brush and watery ink you will find it a quick way of structuring your drawing so that it may be corrected later.

2. Work out any major tonal areas early on, to throw the busier folded regions into relief. Remember to stabilize the figure on the floor, as was explained in earlier sitting projects.

3. With darker colour, and a dip-pen, you can start to detail the folds. Remember that you are not just copying what you see, but attempting to describe the form underneath.

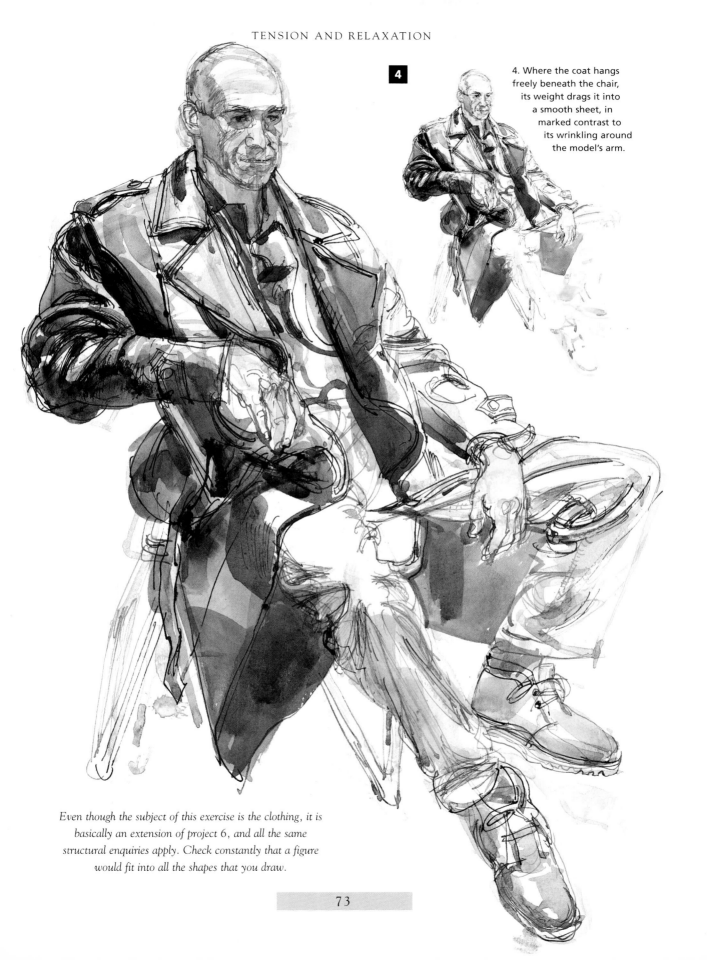

4

4. Where the coat hangs freely beneath the chair, its weight drags it into a smooth sheet, in marked contrast to its wrinkling around the model's arm.

Even though the subject of this exercise is the clothing, it is basically an extension of project 6, and all the same structural enquiries apply. Check constantly that a figure would fit into all the shapes that you draw.

73

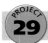

HANGING

*T*HIS PROJECT is going to be demanding on your model, so you must restrict the duration of the poses to ten minutes at most, or take photographs to work from; quick drawing, however, is preferable, as it will prevent you from becoming bogged down by detail.

As has been discussed, the balancing act that we all perform simply by standing on our feet is really extraordinary; akin to standing a pencil on its tip. In this project, the object is to see what happens when the body tips off balance. Ask your model to hang (not completely! this is fundamentally a standing pose) by one or both arms from something fixed above him – a well-wedged door would suffice. He should hang as much as is comfortable; this is not gymnastics, the aim is simply to be seen in the act of

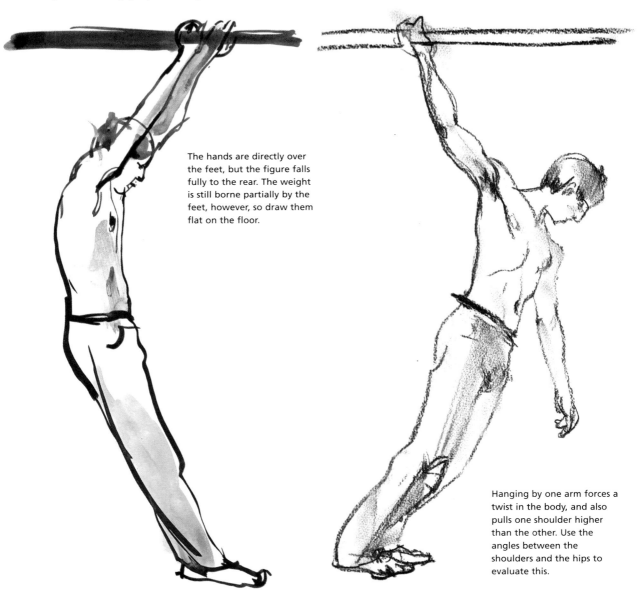

The hands are directly over the feet, but the figure falls fully to the rear. The weight is still borne partially by the feet, however, so draw them flat on the floor.

Hanging by one arm forces a twist in the body, and also pulls one shoulder higher than the other. Use the angles between the shoulders and the hips to evaluate this.

overbalancing, such that he would fall without the tether of his arm.

The striking feature of these poses is the amount of contortion that the body adopts; even when the supporting hand is directly above the feet, the whole figure will fall well out of this plane. When drawing, instead of looking for an outline shape of the figure, look for the *direction* of its components; the overall curve of the body, down the arm, through the back, and down the leg, may be surprisingly pronounced.

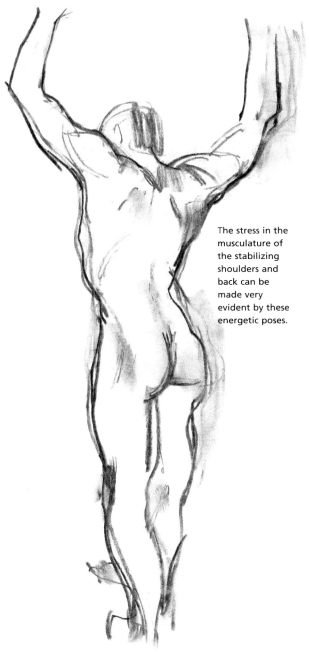

The stress in the musculature of the stabilizing shoulders and back can be made very evident by these energetic poses.

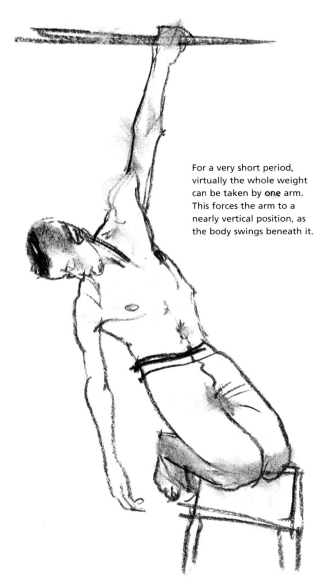

For a very short period, virtually the whole weight can be taken by one arm. This forces the arm to a nearly vertical position, as the body swings beneath it.

Make a number of drawings, allowing your model to change arms and position regularly. Don't 'set up' each pose, just let your model move to new positions when he chooses. If you have your materials and a lot of paper ready, you should be able to produce many drawings in a short space of time, and in these cases it is often the fastest and latest drawings that show the greatest understanding.

Perspective and Foreshortening

BUILDING BLOCKS

ONE OF THE biggest misconceptions that your brain forces on you is that objects like legs should always look long and narrow. Confronted with a leg seen from the foot end, your inclination is to draw the leg as it is more familiar to you, from the side; it can be impossible to believe that something you know to be so slender appears from some angles to be so squat. A good way to force yourself to believe what your eyes are telling you is to remove the figure from the equation altogether, and draw from structures about which you have fewer preconceptions.

Therefore, in this project, try to get hold of some traditional children's building blocks of various shapes (a dusty corner of an old toy shop worked for us). Failing this, gather up an assortment of household empties – bottles, packing tubes etc. The aim is vaguely to mimic some of the solid forms

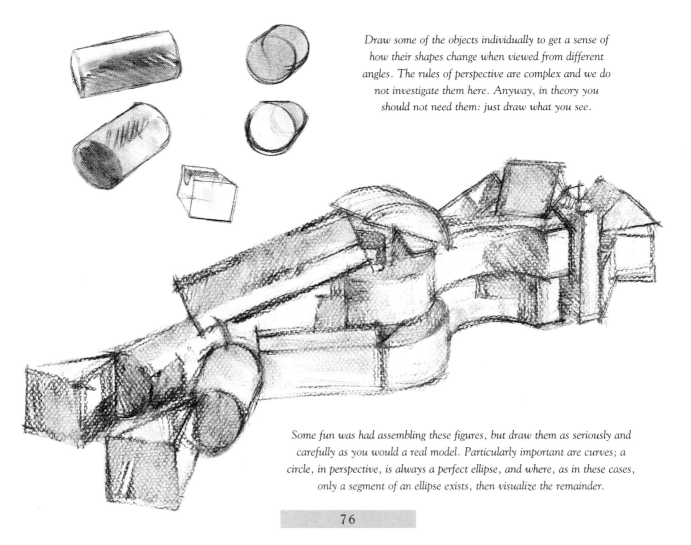

Draw some of the objects individually to get a sense of how their shapes change when viewed from different angles. The rules of perspective are complex and we do not investigate them here. Anyway, in theory you should not need them: just draw what you see.

Some fun was had assembling these figures, but draw them as seriously and carefully as you would a real model. Particularly important are curves; a circle, in perspective, is always a perfect ellipse, and where, as in these cases, only a segment of an ellipse exists, then visualize the remainder.

of the human figure. Begin by drawing the simplest shapes, but from extreme angles: a round tube, seen from just off end-first, can surprise you by how little of its side is visible – draw accurately, however, and your drawing *will* look like a tube seen end-on.

As you become more confident you can start actually to make a figure, or an imaginative approximation of one, out of your blocks. Draw again from extreme angles, and vary your distance from the model to see how that affects the foreshortening. As in earlier projects, look for a shape which will enclose the entire form – this will often be a square, or rectangle, and keep to this shape; it will prevent you from elongating your drawing.

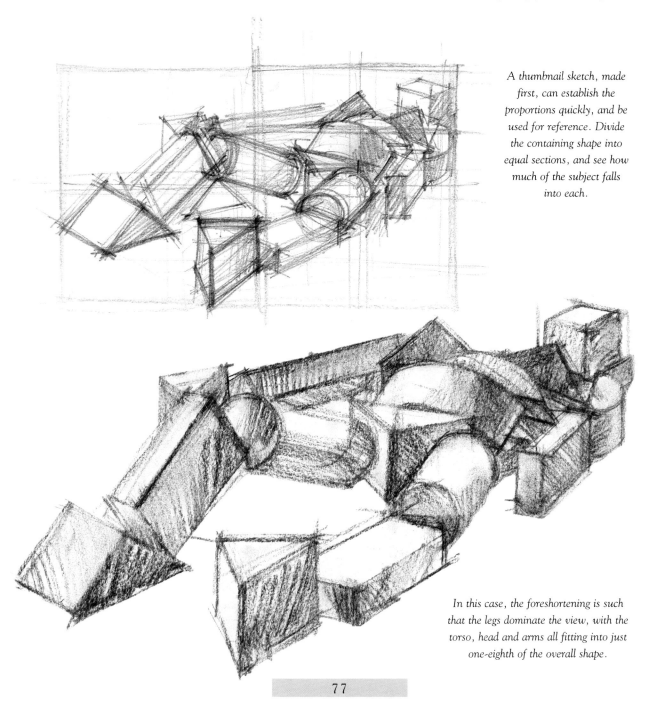

A thumbnail sketch, made first, can establish the proportions quickly, and be used for reference. Divide the containing shape into equal sections, and see how much of the subject falls into each.

In this case, the foreshortening is such that the legs dominate the view, with the torso, head and arms all fitting into just one-eighth of the overall shape.

FORESHORTENED LIMBS

B Y NOW you should be more familiar with the effects of foreshortening, and can return to the real human figure. You can attempt this project without recourse to a model, because you can use your own body.

Position your free arm so that, when seen in a mirror, you observe it from the hand end; you will need some sort of support, like the back of a chair. This is important because any movement, seen from this angle, will result in a drastic change in what is visible to you. Try to see the arm as you saw the cylindrical blocks in the last project, or as you might see a pencil, tip-first. The overall shape

may be nearly a square, and of that area you may find that one enormous fingernail occupies more space than the entire upper arm. *Draw what you see.* Only when these apparently ludicrous contrasts of scale are faithfully observed will the drawing look accurate.

Experiment in this way with your legs and your feet. Usefully, from these positions the complex forms of the structures are often more evident, and economies in your drawing can be more easily made. The apparent twist in a thigh, an illusion conjured up by its particular musculature, is much more obvious when seen from the knee end.

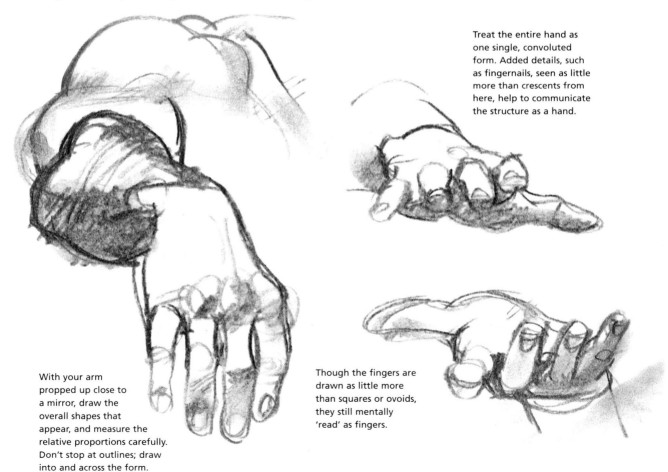

Treat the entire hand as one single, convoluted form. Added details, such as fingernails, seen as little more than crescents from here, help to communicate the structure as a hand.

With your arm propped up close to a mirror, draw the overall shapes that appear, and measure the relative proportions carefully. Don't stop at outlines; draw into and across the form.

Though the fingers are drawn as little more than squares or ovoids, they still mentally 'read' as fingers.

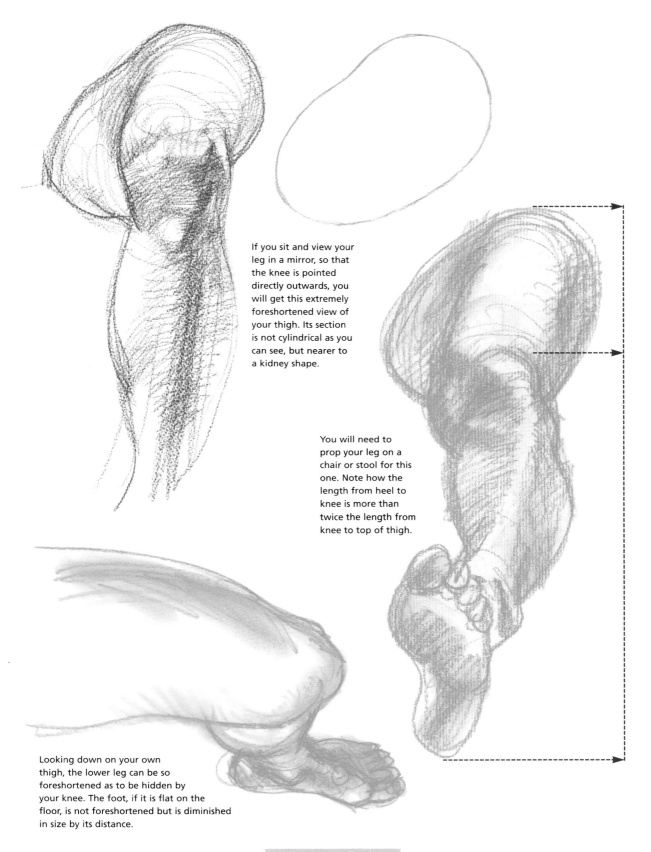

If you sit and view your leg in a mirror, so that the knee is pointed directly outwards, you will get this extremely foreshortened view of your thigh. Its section is not cylindrical as you can see, but nearer to a kidney shape.

You will need to prop your leg on a chair or stool for this one. Note how the length from heel to knee is more than twice the length from knee to top of thigh.

Looking down on your own thigh, the lower leg can be so foreshortened as to be hidden by your knee. The foot, if it is flat on the floor, is not foreshortened but is diminished in size by its distance.

HIGH EYE LEVEL

PROJECT 32

ORESHORTENING IS one of the most consistently feared aspects of drawing the figure. If we really drew just what our eyes perceived, there would be no difficulty. The problem is that the brain interferes and will not let us believe that, for example, a leg, which we know to be a long form, can appear to be an almost circular shape when viewed from one end.

There are various ways to combat this tendency of the brain to intervene and cloud our objective vision. One way, of course, is to measure. As you can see in the diagram below, the actual lengths, in terms of the space they occupy in your vision and on the page, of various dimensions which from a normal upright view would be quite long, are seen to be very short. Not only that, but they become shorter as they are further from your eye, i.e. perspective applies to the human figure just as it does to disappearing railway lines!

Another quicker way to highlight the apparent 'distortions' of a foreshortened figure is to view the whole or parts of the figure through a square or rectangular aperture cut in a piece of card (fig.4). The rather surprising fact that a full-length figure is contained within a square should convince you not to be tempted to draw it much longer.

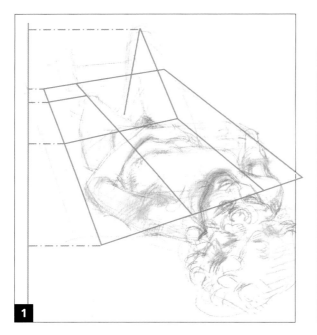

1

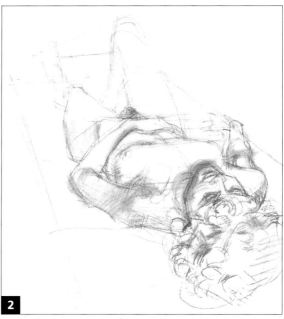

2

Choosing your spot

If it is difficult to arrange a view from above a standing model – a severely foreshortened view can be achieved by viewing a prone model from the head or the feet.

1. This diagrammatic view of the drawing demonstrates the surprising effects of perspective. The lower leg occupies the same space on the page as the distance between one eye and the nose.

2. In these cases, the early construction of your drawing is crucial. Don't draw too much into the figure at this stage, as it is very easy to get 'led' off to inaccurate proportions.

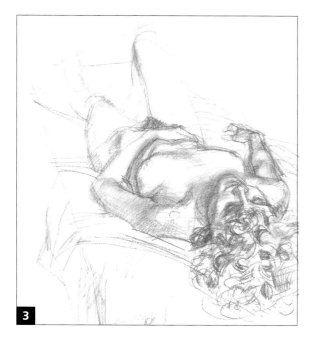

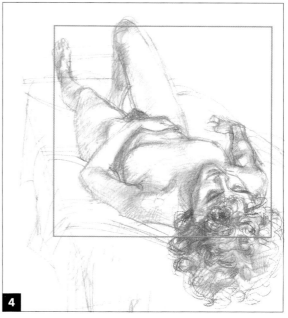

3. As you draw the actual shape and form of the figure, constantly re-check the proportions. The edges of the mattress are particularly useful reference points to measure from.

4. This entire figure, without all its tumbling hair, fits neatly into a perfect square. Finding overall shapes like this can help to keep your whole drawing in check.

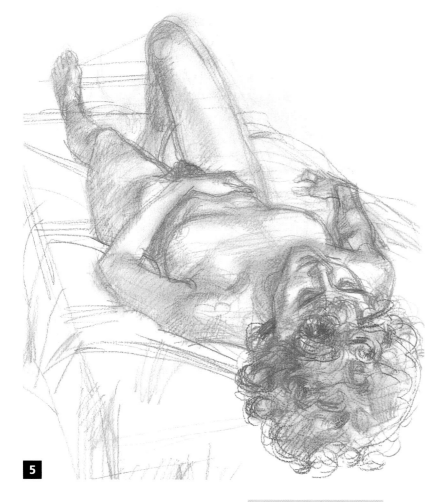

5. The finished drawing remains basically structural, but the constant reappraisal has produced marks which, almost incidentally, effectively describe the solid form of the figure.

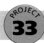

LOW EYE LEVEL

PROJECT 33

*J*UST AS, in the last project, a high eye level was simulated by viewing the reclining pose from the head end, a low eye level can be simulated by viewing the same pose from the level of the feet. Certainly foreshortening is the same whatever the eye level – it depends on the apparent length of objects being diminished when they are viewed end on, so to speak. So recumbent figures viewed from one end or the other are foreshortened in exactly the same way as are standing figures looked at from low and high viewpoints.

However, although it can be quite difficult to arrange a high eye level view of a standing figure, especially if you are drawing as a group, it is much easier to obtain a low level view by simply standing the model on a table. The foreshortening will not be as extreme as the view from the feet end of a reclining pose, but the additional elements

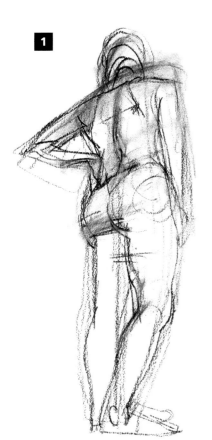

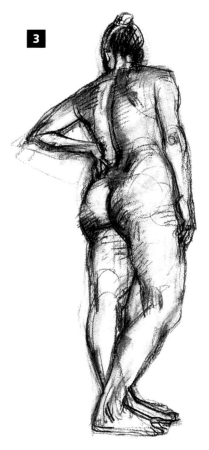

1. The foreshortening of this pose is not as extreme as in the previous project, but the twist in the body means that it is particularly affected by perspective. Draw across the parallels in the body, the hips, shoulder blades and shoulders, to find their relative angles.

2. If you can find your eye-level on the drawing (in this case, mid-calf), then you can ascertain whether you are looking up or down at different parts of the figure. Here, though the pose is elevated, we are actually looking slightly down on the feet to see their top surface.

3. If there is some directional light falling on the model, then use it to define the form of the figure. Here, the lower back, where it turns away from the buttocks, has been emphasized as escaping the light, and this helps define the curve of the entire back.

4

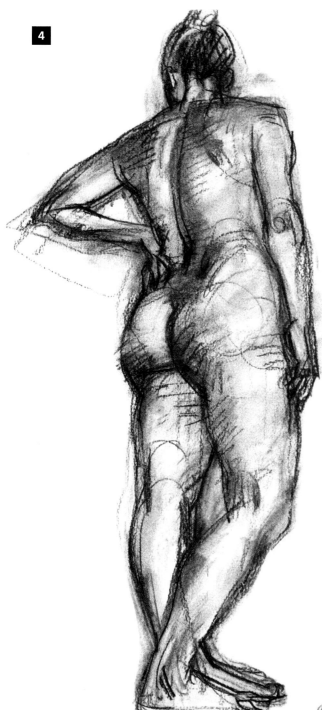

of balance and 'tall building' structure (see projects 8 & 9) make it a testing and useful exercise.

If you are really keen to tackle foreshortening, you could try an extreme view from the soles of the feet, as below. It is not as difficult as it looks, as long as you forget what you 'know' about the length of the figure and truly draw what you see. A viewfinder cut from card is again very useful to help you believe the shapes that you see that your rational brain finds hard to accept.

The full-length figure can be difficult to measure accurately. Look for points which are exactly half-way up or across the figure. Any regular feature, like bookshelves on the wall behind, will help your measurement. If you find it useful, then actually draw lines, or stick tape, on the far wall at regular intervals. It is still crucial here, as in any balancing pose, to establish the centre of gravity, and where it divides the figure.

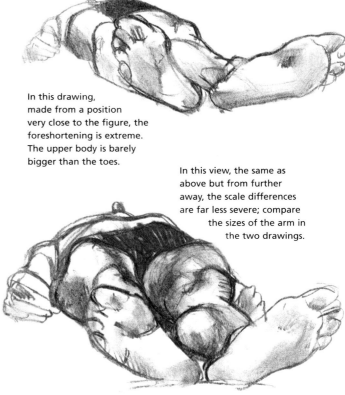

In this drawing, made from a position very close to the figure, the foreshortening is extreme. The upper body is barely bigger than the toes.

In this view, the same as above but from further away, the scale differences are far less severe; compare the sizes of the arm in the two drawings.

4. If this figure were closely encased in something like a tall fish-tank, then you would be looking almost squarely up to its top surface, yet still obliquely down to its bottom (the floor plane). As you finish your drawing, go back and make sure that the early construction marks still apply.

SECTION 3
Colour

This book is about drawing; painting is not mentioned in the title, so what has colour got to do with it? Well, the action of drawing involves more than just making lines. Drawing with charcoal and pastel leads you to making broad marks representing tones and it is a short step from there to making the same sort of marks with a paint-laden brush.

So, what do you need to know about colour? There exists a great deal of theory applied to colour involving wavelengths of light, reflection and absorption etc. which you may want to pursue elsewhere. We propose to limit the theory to a few basic principles. Remember that artist's pigments are just coloured substances, mostly powdered, that are mixed with adhesives or oils to enable them to be handled and applied to a surface. Good though they are nowadays, they do not have the purity of the colours of the rainbow, which are the result of splitting white light into its components, and you need to know their limitations.

The exercises that follow are intended to demonstrate which paints you really need in order to match all the colours that you are able to perceive. Some readers may feel that they have left such basic stuff behind them, but it is surprising how much you can still learn from them about colour mixing and possible colour co-ordinations. We suggest that beginners and more experienced alike should try them.

Colour

THE SPECTRUM

*S*OME ARTISTS like to work with a limited palette of colours, and the method has some advantages, but we suggest that you should first try the following exercises to ascertain what pigments you need to give you the best chance of matching every colour that you can see in life.

You will need the following colours

Ultramarine blue, Prussian or Windsor blue, lemon yellow, any mid yellow, scarlet lake or vermilion, magenta or permanent rose, turquoise blue and viridian or Windsor green.

Step 1. *Draw a circle with a compass and then, with the same radius, mark off six equidistant points around the circumference and join them to divide the circle into six equal parts. Divide these again to make twelve marked segments and number them. Alongside this circle, draw two sets of three smaller interlocking circles as shown. Now fill the outer segment of one of the triple circles with the mid yellow and paint the same colour in position number 12 in the big circle. Add the Windsor blue and magenta to the same triple and also to positions 7 and 4 respectively on the large circle. Do the same on the other triple, with ultramarine blue (position 6), lemon yellow (11) and scarlet lake (3). Red, blue and yellow are considered to be the primary colours.*

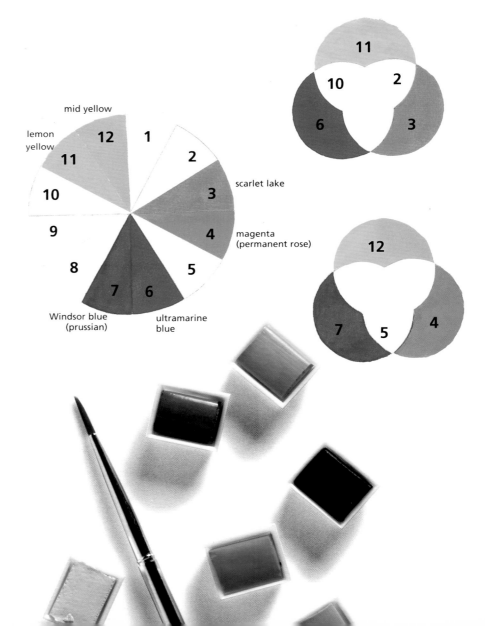

Step 2. *Now mix together the adjacent colours in the interlocking circles. As you will see, scarlet and ultramarine make a sort of brown colour but magenta and Windsor blue make a very good purple (although ultramarine and magenta makes an even brighter one see fig below right): put this in position 5. Both pairs of yellow and red make clear orange, the best of which (mid yellow and scarlet should be the best) can be put in position 2. The yellows and blues make not very intense greens, the cleaner of which can be placed at position 10. These combinations of primaries are known as secondary colours. Complete the triple overlap with a mix of all three outer colours, called tertiary colours.*

Step 3. *You will see that there are now three gaps in the colour circle. Position number 1 can be filled with a mix of 12 and 2, but the strong green at 9 cannot be mixed and must be provided by the Windsor green pigment. Lastly, the space for blue/green or turquoise is filled with a manufactured turquoise pigment, which could be mixed but is likely to be less clear than this. So you see, to cover the spectrum, any old red, blue and yellow will not do: you need at least two blues, two reds, a yellow and a green.*

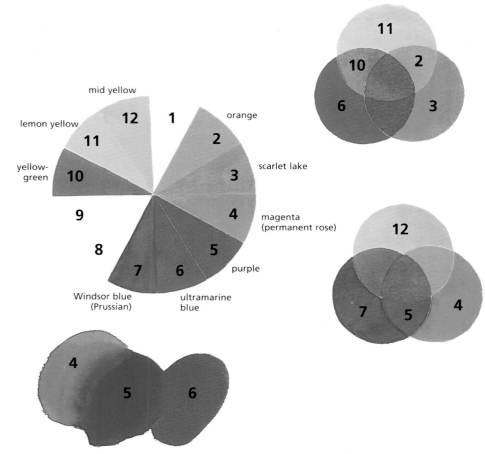

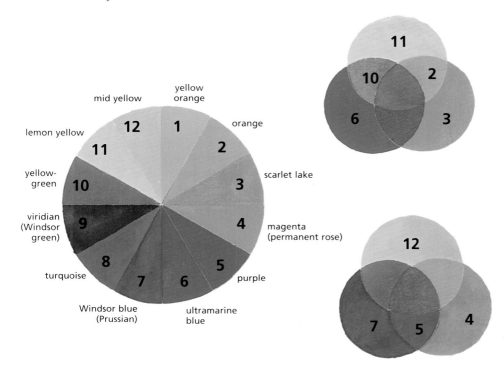

MIXING AND MATCHING

*I*F YOU have completed the exercise on the previous page you will now have a circle of colours representing the spectrum. At this point we would like you to draw a line across your circle, as shown right, dividing the yellows, oranges and reds from the greens, blues and purples. The former are known as the warm colours, the latter as the cool ones. This concept of colour temperature is a very useful one, as you will see later.

All these colours can be made paler by gradual dilution, and infinite gradation of hue can be obtained by mixing close neighbours in the colour circle. Mixing colours that are *across* the circle from each other, however, makes less clear, dirtier colours. Theoretically hues exactly opposite one another in the circle (complementary colours) mix to make grey, but in practice this not always exactly so.

Exercise 1 invites you to discover what happens when you mix complementaries together in different proportions.

Exercise 1

Mark out a row of six or so squares, about 5cm square. Choose any two pairs of complementary colours from the colour circle and put them in squares at opposite ends of the row. Suppose you have chosen scarlet and viridian: add a touch of viridian to a lot of scarlet and place the mix in the square next to the scarlet. In each succeeding square add

more green to less red until the square next to the green is nearly all green with just a touch of scarlet. Try the same technique with other complementary pairs and see the bright primary colours at the outer ends transmute into a rich and complex array of browns and greens in the middle.

Exercise 2

Although the use of black pigment is often advised against, adding black to spectral colours is a fast route to many rich tertiary colours and so it is a very useful paint to include in your palette. For this exercise, choose any colour from the circle spectrum and with your fingertip, dab a circular patch of the pure colour near the corner of your paper, as shown. Then, by dabbing your finger into very small, but increasing, amounts of black, modify the pure hue in the vertical first row little by little, until nearly black at the top. Next, modify each of these in a direction right-angled to your first series, by dabbing more and more white. You should end up with the greyest version of your original colour at the opposite corner of your grid and the darkest and lightest colours at the other two corners.

darkest hue greyest hue

starting hue lightest hue

Exercise 3

If the original colour that you chose was in the warm area of the spectrum, some mixings with black will resemble the earth colours, so called because the pigments are prepared from ground-up rock and earth, the best known being raw and burnt umber and raw and burnt sienna. We recommend that, for ease and speed, you include these pigments in your working palette, but to underline how easy they are to match, try adding a touch of black to orange to match raw sienna, and a bit more to produce raw umber. Similar quantities of black added to scarlet lake will make burnt sienna and burnt umber. It is difficult to match black itself, but a mix of ultramarine blue and scarlet lake comes close.

black

raw sienna

burnt umber

raw umber

PROJECT 36

TRANSPARENT COLOURS

*M*OST GOOD pigments are transparent until they are mixed with white, and this gives us another way to lighten their tone. If they are thinned by adding a medium such as water or turpentine and applied over a light ground, they will allow the ground to shine through. Colours lightened in this way have a luminosity that opaque mixings lack. Furthermore several layers can be applied on top of each other to adjust colour intensity and tone without sacrificing the influence of the light ground beneath. Application of transparent washes to make use of this reflected glow is the basic principle in the traditional watercolour method. In its purest form, watercolour uses the white of the paper as the lightest tone and by adding wash over wash gradually achieves the darker ones. It is one way, light to dark, and you cannot go back and make a wash already applied lighter.

Acrylic paints and inks can be used in the same way, and oils too to some extent, although it is somewhat limiting to their potential.

We invite you in this project to explore the use of transparent washes in depicting the figure in light and shade, without recourse to lines. In this way you will define outer edges of the figure solely with washes of colour and tone.

1. More than any other medium, watercolour requires particular attention to planning and technique. Work tonally, and start by laying down all of the broad areas of tone with light, very watery washes.

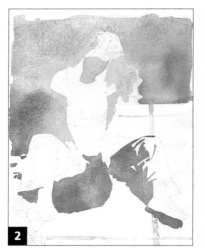

2. Gradually refine the shapes, half-closing your eyes as you go to clarify your awareness of the respective tonal variations. At this stage, however, there are still only three or four grades of tone across the entire image.

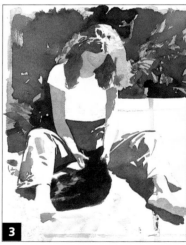

3. If you are sure about the placement of some darker regions, then put them in. If you are not sure, but like them, then put them in anyway. 'Happy accidents' are a backbone of this medium, and experiment leads to useful discoveries.

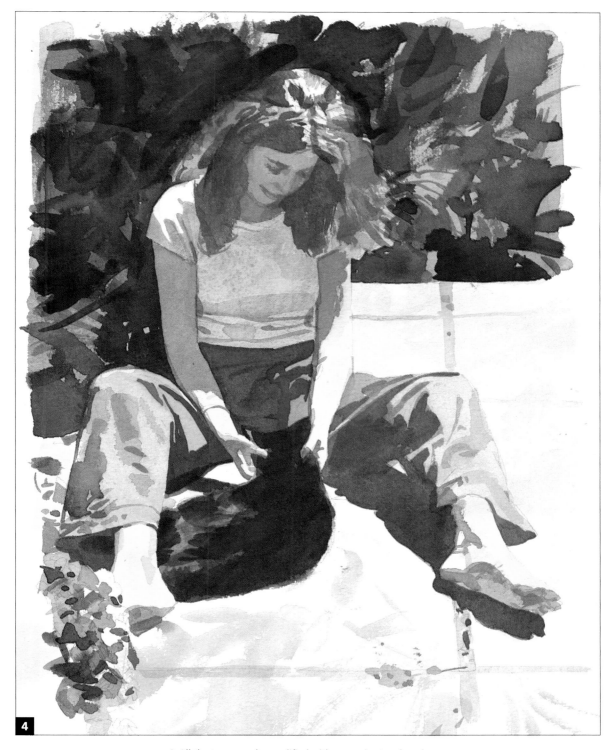

4 4. All the tones can be modified with successive tonal washes. Pay particular attention to the colours in the shadowed areas, and stress them if you like; remember, the object is to explore the luminosity of layered colours as they are affected by the white paper.

OPAQUE COLOUR

PROJECT 37

*T*HE FUNDAMENTAL advantage that opaque colour has over a transparent one is its adjustability. With the possible exception of pastels, all opaque media can be moved around on the surface or overpainted completely, which means that you can paint from dark to light just as easily as you can the other way. The disadvantage is that transparent effects are unavailable, which is why most quality paints include many transparent colours that can be made opaque by the addition of white if need be. Most painting methods employ a combination of clear and solid colour. In this exercise, we ask you to restrict yourself to opaque colour and, for this purpose, gouache paint is ideal.

Because every mark you make, every colour, dark or light, can be overpainted, you can be very free with the way you start a picture using gouache. Your

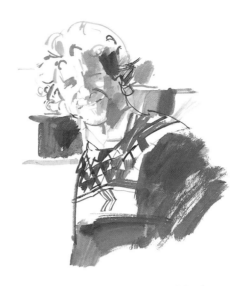

1

1. Because the paint used here is opaque, enabling later applications to overlay or obliterate the first marks, you can be very bold and free from the outset. Bright red and dark brown have been used as well as more restrained colours to map out the first shapes.

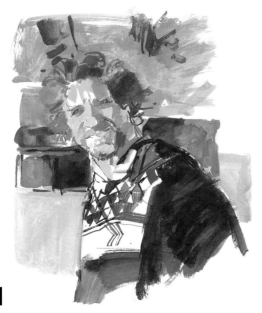

2

2. Stronger yellow-orange flesh tones have been added to the light areas of the face, the main tones of the hair and the background shapes of sunlit trees and boat sides blocked in. Try to cover the white of the paper as soon as you can so that you can better assess the tonal balance of the whole picture.

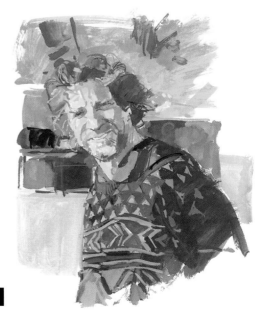

3

3. The superstructure of the boats has been treated quite abstractly, just as a background to the lively head. Having left some of the triangles and lines on the pullover as a guide, the rest of the background brown was painted and overlaid with the pale green pattern.

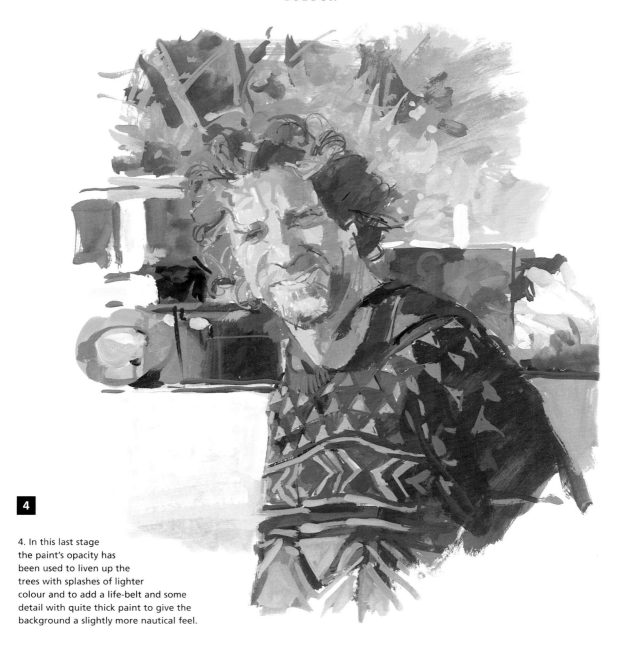

4

4. In this last stage the paint's opacity has been used to liven up the trees with splashes of lighter colour and to add a life-belt and some detail with quite thick paint to give the background a slightly more nautical feel.

construction lines can be any colour and it can sometimes look good if you use a bright colour for them and don't completely obliterate them under subsequent layers. Applying paint by dragging it over existing paint, so that some of the underpainting shows through, is called *scumbling* and it adds excitement and richness to paint surfaces. When using only opaque paint, there is a danger that the colour will have an all-over matt and dull appearance: scumbling and other broken colour painting replaces the excitement lost by the lack of transparency.

A word of warning – since gouache is a water paint, succeeding layers of paint are not isolated from each other. As a consequence, there is a tendency for later applications to soak in and become a different colour when they are dry from the colour that they were when first applied wet.

PROJECT 38 — TRANSPARENT AND OPAQUE COLOURS

*W*HEN USING paint, one of the key aspects to control is its transparency. In oils, acrylics, and to some extent gouache, the darker colours are generally more transparent, and the lighter ones are more opaque. The established way of using these paints is to keep the darker areas free of opaque paint, and build them up as a succession of thin, clear layers, as you might use watercolour. The effect created is an illusion of depth. The mechanics of this phenomenon are complex, but if you are technically curious, there are several books available which describe in great detail the optical effects of layered paint films.

In the lighter areas, as the form turns into the light, more opaque and physically thicker paint is used; most white paint is almost entirely opaque. The thicker paint actually catches the light, making it appear lighter still. The overall illusion of light and shade is more powerful than if consistently opaque paint is used.

Set up your model in a comfortable position so that there is an obvious contrast between the areas of light fall and the shaded areas, and try to include some variance in the surroundings; colourful fabrics perhaps, and some solid forms – cushions, bedding etc. It is a good idea to work on a light-coloured surface, like stretched paper, as this will provide some luminescence to shine through for your clear colours. Use transparent paint, with absolutely no opaque colour, simply to map out the tonal areas and, as the composition is established, introduce the whites only in the most lit regions. You will probably find that you spend two-thirds of the time without using any solid colour.

1. Begin in the same way as you did for the previous project, bearing in mind that, as you will be using opaque colour, mistakes can be more easily rectified. You can use the lighter paper temporarily to represent the lit areas, even though they will eventually be painted.

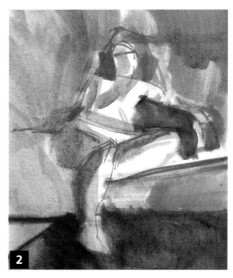

2. Although this is basically a tonal exercise, you can use lines to confirm the structure of your model. The thin oil paint used here dries quickly, but can still be moved around to an extent. Don't worry if some parts get too dark – you can sort this out later.

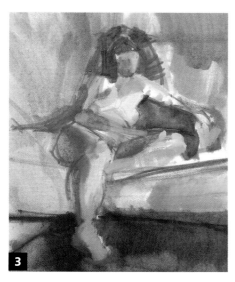

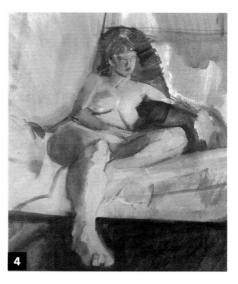

3. Introduce opaque paint into the lit areas when you are satisfied that the structure and tonal range is established. The paint will need to be quite dense and undiluted if it is to cover. Work quickly, to lose any white paper, which is distracting.

4. Re-evaluate the look of your original transparent paint with regard to the opaque paint, and use clear washes to modify the darker areas. Remember that very little of the composition will actually be bright white.

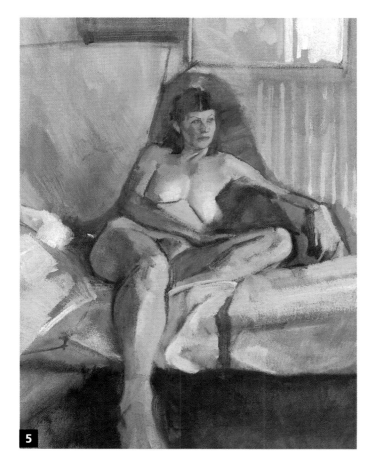

5. If you need to redraw, which you probably will, you can apply transparent colour over (dry) solid colour to reclaim the luminosity. A complex form like this knee can be described with a subtle application of opaque colour into clear dark areas.

THE COLOUR OF FLESH

PROJECT **39**

*W*HAT COLOUR is flesh? It is a question often asked and the answer is that it consists of and contains every colour. The colour of the light falling on skin, the colour of reflective surfaces nearby, the degree of moisture-induced shine, the natural pigmentation which gives such a range of colour to all races – all these factors combine in the perceived colour of the human face and body.

So-called white skin varies in density all over the body and the blood vessels which make it appear pink vary in their proximity to the skin's surface. This extra redness is usually seen in the face generally, but especially in the nose and cheeks, and also in the wrists, hands, ankles and feet. In darker skin, which is not so transparent, this effect is less obvious, but there is often a rich range of colours in the shadowed areas and the very darkest skin may show bright reflected highlights.

To explore these effects fully and to develop your response to skin tones you will need to make studies of many differently complexioned models in a variety of light conditions, but for the moment we suggest that you look for a model who is basically light skinned and untanned. Untanned, that is, on the parts of the body that are normally covered by clothing. The consequent contrast between the warmer coloured head and hands and the cool, transparent skin on the parts of the body that are shielded from daylight will give you ample opportunity to investigate the range of colours that can be found in skin. This search for colour can be quite personal and subjective. Ask yourself if that knee, or belly, or those toes appear reddish, or blueish. If you think you can see the slightest tinge of colour, trust your decision and put in the colour boldly.

1. The initial stages of this painting involve selecting the colour, rather than just the tone of the image. Although tonal values must be observed, let yourself be led by the local colours.

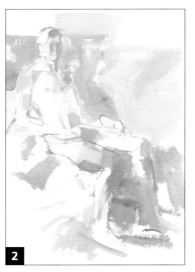

2. You can push the tonal values until they are almost reversed, as long as the colour makes sense. Here, the bright yellow on the far side of the torso is still understood as defining an area turned from the light.

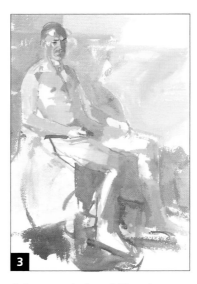

3. Opaque paint is useful here, because if the definition of the figure begins to run out of control, you can re-describe the form with some well-placed slabs of colour.

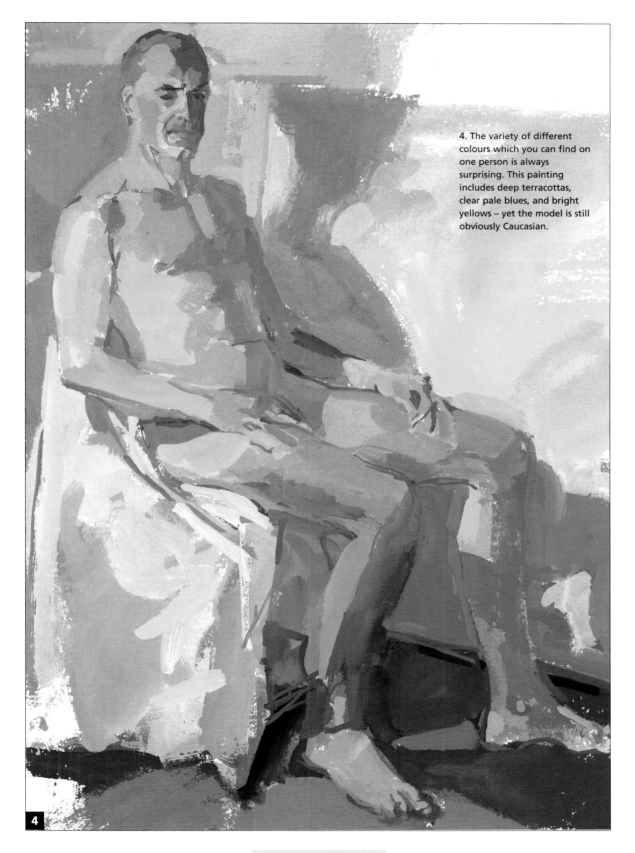

4. The variety of different colours which you can find on one person is always surprising. This painting includes deep terracottas, clear pale blues, and bright yellows – yet the model is still obviously Caucasian.

Advanced

The following chapters are about applying what you have learned so far to more challenging situations. In Section 2 we looked at the figure as a dynamic structure, but in fundamentally static conditions. The far more interesting reality, however, is that people can run and jump, and squeeze and bend their bodies into a huge variety of different shapes. The next projects may be thought of as an extension to Section 2, but with the emphasis on the curiosities that can occur when a figure is twisted and folded, rather than simply describing it as a stressed structure. Then we address a subject which is fully deserving of a book to itself – movement.

The study of movement of any kind only really matured in the twentieth century, with the development of high-speed photography which could effectively 'freeze' moving subjects. We maintain that the only way to develop an understanding of the motion of a fast-moving object is to photograph it.

Composition is also examined in this section, and this is another huge subject. It is important when you are experimenting in the early stages of drawing that you are unconcerned about composition, as form and proportion are difficult enough to deal with, without complicating matters further with pictorial concerns. As you become more confident in these basics, however, then control over the arrangement of your drawing on the page becomes increasingly important.

Twisting and Bending

*I*N SOME ways, these next projects are similar to the exercises in Section 2. The emphasis here, however, is on investigating the range of shapes and positions that the human body can get itself into, rather than on analyzing poses to understand the effects of gravity on the human figure. For a structure that is defined by a series of inflexible beams (the skeleton), the figure displays a remarkable ability to appear to be something else entirely, something more elastic and fluid.

With this first project, your aim is simply to investigate the extent of these contortions. This is another situation in which your model will need to assume positions which will be uncomfortable to hold for any length of time; two or three minutes might be the maximum for some poses. The restriction which this places on you is useful, nonetheless, as it will force you to edit your drawing down to only that which is essential. If you have read the book through from the beginning, this advice may seem to be getting repetitive: it is crucial, however, as even the most advanced draughtspeople can easily be sidetracked by details at the expense of the whole.

Ask your model to adopt a wide variety of positions, and to vary them equally between sitting, standing and reclining poses. The factor common to them all is that they should push the model to the limit of his or her flexion. Look for the most unlikely and extreme shapes that arise, and, as you draw, scrutinize the parts of the body that seem to be most stressed, and focus your attention on them. Draw fast, and decisively, and move around the model to find the best views. By the end of this project, you should be at least as tired as your model.

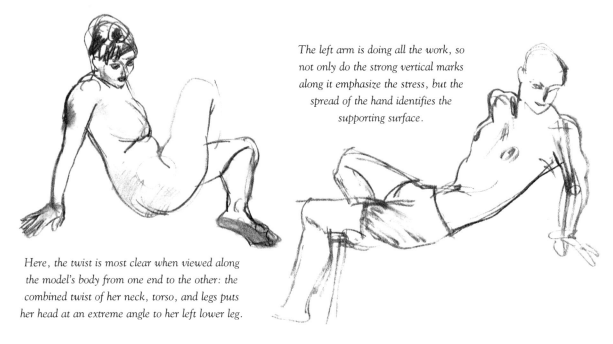

The left arm is doing all the work, so not only do the strong vertical marks along it emphasize the stress, but the spread of the hand identifies the supporting surface.

Here, the twist is most clear when viewed along the model's body from one end to the other: the combined twist of her neck, torso, and legs puts her head at an extreme angle to her left lower leg.

The physical stress is particularly divided here; the model's weight is supported in compression by his rearmost leg and right arm, and in tension by his left arm. This induces completely opposite stresses in his shoulders.

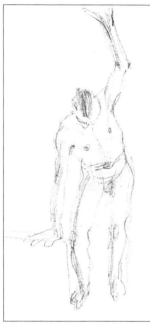

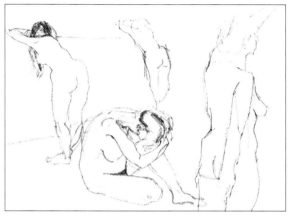

Ask your model to move around a space while you remain stationary; without your interruption, the model may find more natural and varied poses of her own accord.

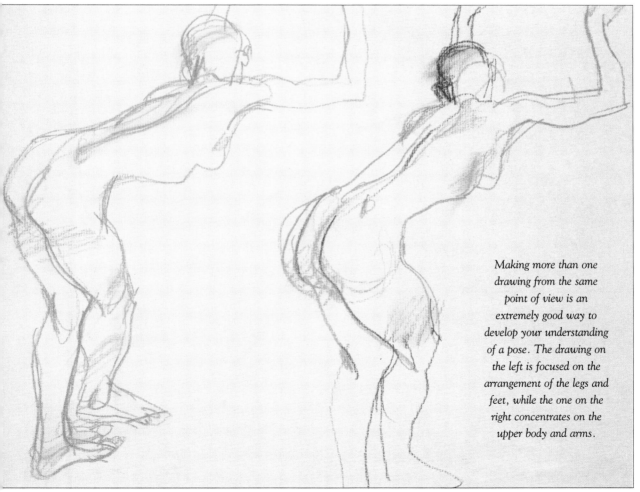

Making more than one drawing from the same point of view is an extremely good way to develop your understanding of a pose. The drawing on the left is focused on the arrangement of the legs and feet, while the one on the right concentrates on the upper body and arms.

SITTING

AS YOU become more confident at drawing these dynamic poses, you can start to investigate some of them more closely, by taking more time to make more inquisitive drawings. The first obvious problem is that your model will not be able to maintain traumatic poses for long; therefore the amount of torsion demanded must be less than in the last project. However, it is probably preferable to grant your model frequent breaks (even every five minutes) than to compromise on positions. You should be spending about half an hour on each drawing in these projects.

'Dynamic sitting pose' might seem to be a contradiction in terms, but a chair can be used in many different ways, and is a useful apparatus for stabilizing a twisted human body: look at the positions that people adopt voluntarily in bars and cafés, when sitting on chairs which were designed to be used in only one way – feet up, sitting backwards, leaning over/off the back…use these as cues for your own set-ups. Also look at the way in which people balance themselves when they are in the process of sitting down or getting up. Although movement will be more thoroughly investigated in the next sub-section, a person who is rising out of a chair may be considered as a stressed structure, as featured earlier. Ask your model to hold a position whereby she is just getting up, or about to – and concentrate on how she prepares to support her weight as she makes the transition from sitting to standing.

2. This elegant pose, when adopted by a muscular model, offers a superb opportunity for investigation of the musculature of the back. Though stable and comfortable, the twist along the spine is almost ninety degrees, and, as the weight is taken fully by the chair, the relaxation in the legs contrasts with the stressed shoulders.

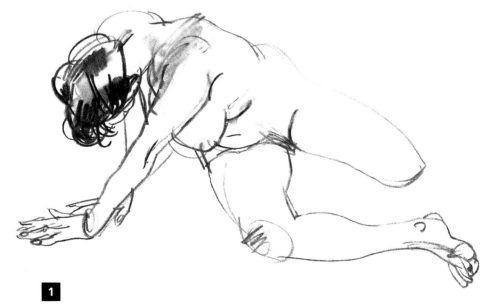

1

1. This model is somewhere between sitting and lying down, in that she has twisted herself to such an extent that her arms are supporting much of her weight. This may be considered as a 'moment' in the process of getting up, and this movement is identified in the evident strain showing in her nearer shoulder.

3. In this case, the model is actually hanging from a support, or perhaps more accurately stretching to grasp it. Again, the twist along the spine approaches a right-angle, but this time the left shoulder bears all the leverage, and this is the fulcrum for the rest of the pose and for the drawing.

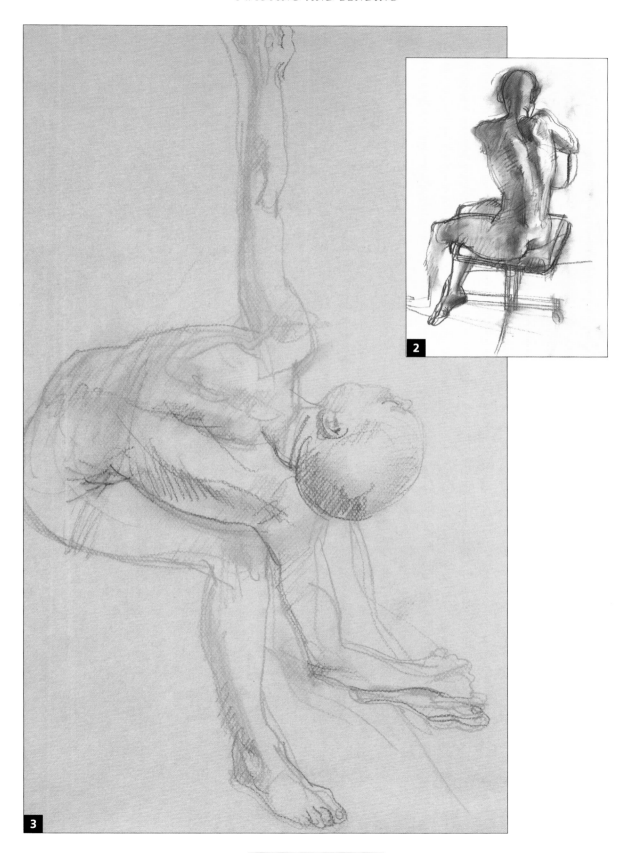

PROJECT 42 STANDING

*T*HE STANDING human figure is restricted in its movement by the necessity of remaining balanced on a small platform. Most large dynamic shifts are the result of the figure being in motion, such as running or jumping, in which cases the figure is off-balance for most of the time. Nonetheless, the dynamic states that the static standing figure can maintain are particularly interesting specifically because they require only a small platform for balance.

The easiest and most obvious sorts of poses are simple twists of the upper body, which can demonstrate the supple flexibility of the human back. The use of props, however, can widen the range of shapes that are available to you, especially if hanging poses are invoked – recreate some of the poses from project 29, but instead of focusing on the overall balance (don't ignore it – these drawings require confidence in the basics), look closely at the specific way that the body contorts in response to the stress. The frequent rests required by the model, and the subsequent difficulty in finding the correct position again, should not be viewed as a problem. Rather like drawing fabric, your aim is to discover which are the most important aspects and shapes of the pose, and even though the details may change, the overall shapes will reappear. Also, in these inevitably energetic drawings, some forced redrawing will not be a problem, and will probably be to their ultimate benefit.

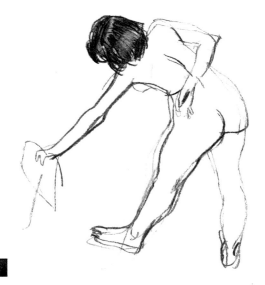

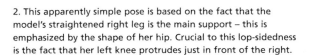

1. Note here that the model's right leg and left arm are supporting this pose; her left leg is simply resting. It is positioned, however, so that it is about to become the main support – suggesting that she is walking over to the chair.

2. This apparently simple pose is based on the fact that the model's straightened right leg is the main support – this is emphasized by the shape of her hip. Crucial to this lop-sidedness is the fact that her left knee protrudes just in front of the right.

3

3. This pose is a straightened variation of one illustrated in the previous project. It presents some foreshortening difficulties, particularly in the drawing of the right leg. Although the drawing on the page is effectively vertical, the figure is actually bent at the waist to a considerable degree.

4. Investigate if you can these sorts of striding poses. The amount of twist that the spine experiences simply when walking is exemplified here. Also note the contrast between the relaxed and swinging left arm, and the movement and stress apparent in the right.

4

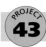

RECLINING

PROJECT 43

*V*IDEO FOOTAGE of people sleeping demonstrates the extraordinary range of positions that we find comfortable when lying down. Freed from the obligation to balance, we happily compose our bodies into ever more peculiar arrangements. Even when a lying figure is twisted into complete asymmetry, the amount of muscular stress experienced may be minimal, as the supporting surface is propping up the figure along its length – the precise opposite of the conditions experienced by a standing figure, which must balance precariously. In this project, then, the necessity for frequent rest breaks for the model is lessened.

Ask your model to take up reclining positions, similar in their degree of twist to those of the previous two projects. There is no particular need for the figure to be straight, so try curled-up poses, and different supports – a pile of cushions heaped on the floor for support may encourage more interesting shapes in the figure than a flat mattress.

The common factor in all these poses is that they will not betray much tension in the body. Other positions which require more effort can be attempted, rather like horizontal versions of standing poses. An athletic model may be able to hold variants of the press-up position for three or four minutes, positions which involve the entire musculature of the back, making the complex surface form evident.

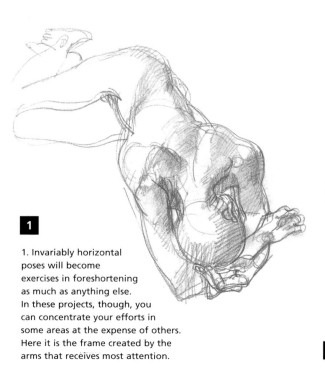

1

1. Invariably horizontal poses will become exercises in foreshortening as much as anything else. In these projects, though, you can concentrate your efforts in some areas at the expense of others. Here it is the frame created by the arms that receives most attention.

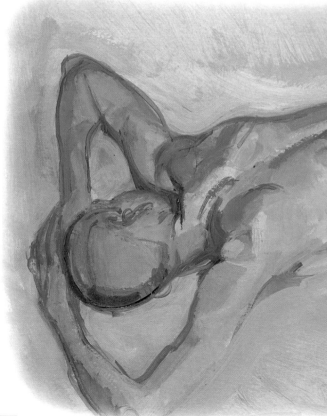

2

3

3. The twist of the back may be localized: it need not be spread along the spine. Here, it is focused just above the waist.

2. A muscular figure stretched out reveals the deepest structures of the body – here almost resembling an insect with jointed legs. A reclining figure cannot really topple over, so the effects of gravity are less significant.

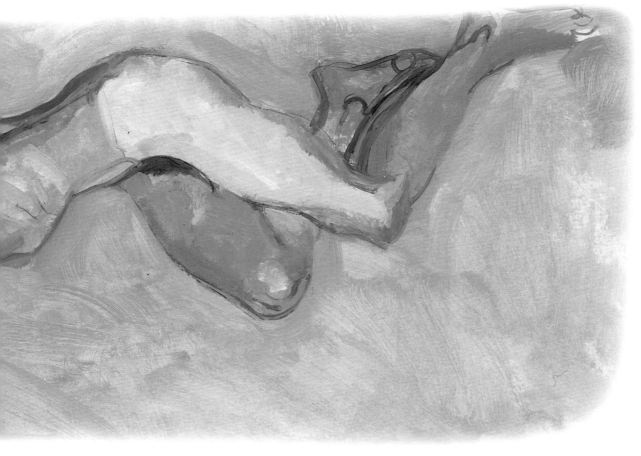

Movement

SKETCHING ACTION

*F*IGURES ON the move cannot be studied in quite the same way as posed and immobile models. You must still try to search out the fundamental overall shapes – indeed it is even more necessary to ignore detail and go for the essence – but it must all be done at high speed. However quick you are, however, it is just not possible to draw instantaneously, which you would need to do if you wanted to observe and faithfully record a single moment captured during even the relatively slow movement of a walking figure, let alone a running or jumping one. The only way is to memorize the instant and draw from that image in your head. Some people naturally have a good visual memory but most of us are unlikely at first to remember very much from such a brief glimpse, although practice can improve the amount of information that we are able to recall.

If actions are repetitive, you can take the opportunity to look again at the particular sequence of the action you are trying to record, building up a complete picture piece by piece.

To begin improving your speed and visual memory, take a sketchbook to a crowded, but not too fast-moving, situation, such as a market, find a comfortable vantage point and draw as much and as quickly as you can. Don't worry about being unable to finish figures; just capture what you can and move on to the next one, letting the sketches overlay one another to build up the scene.

Above: This drawing was made at the Natural History Museum in London. The dinosaur, about as motionless as anything can be, provided a strong framework, around which people could be quickly recorded as they paused momentarily.

Above: This street square, in the Jewish Quarter of Kraków, Poland, was lined with casual locals, meeting and chatting. If you draw the environment fairly accurately, this will give you a framework on which to place any figures that you get a chance to sketch, and the drawing can be built up bit by bit.

Left: Street celebrations, like the Notting Hill Carnival in London, may provide a wonderful combination of people and subjects, if you can find somewhere to sit down to draw. This view, of people climbing up in a porchway to see the parade, was chosen because of the variation in scale of the people as they recede into the doorway; and because, the carnival being so busy, nobody could change position much even if they wanted to.

Above: Markets are always good places to draw, particularly because most people are busy and tend not to pay too much attention to you.

HIGH-SPEED FROZEN

BOVE A certain speed, effectively slow walking pace, it is impossible to recall enough of an object in motion to draw anything but the most simplified impression and even then you may still get it completely wrong.

Consider how, for centuries, galloping horses were drawn with their front legs stretched out together at the front and their back legs simultaneously extended backwards, all four hooves off the ground.

Only when the motion was frozen in a series of photographs taken by Eadweard Muybridge in 1878, made by cameras triggered by trip wires as the horse galloped past them, was the real, much-more-complicated action revealed. Although there was a moment when all the hooves were indeed in the air, it was when the legs came together under the horse's stomach and not in the outstretched position as artists had hitherto painted it.

This drawing of a French humane bullfight clearly required photographic reference. However, careful control of the marks used results in a drawing that fully communicates the drama of the scene.

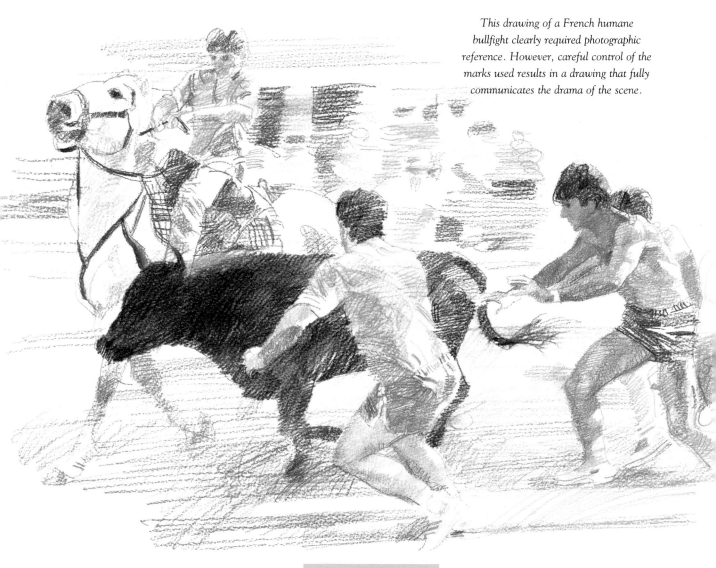

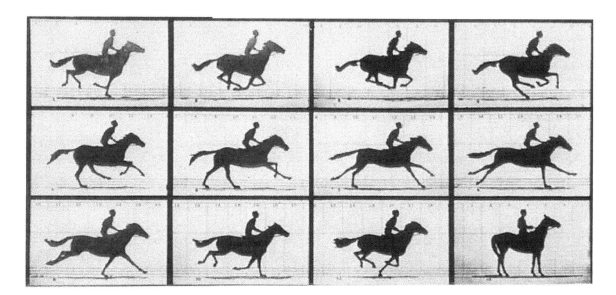

Above: This famous sequence of photographs, taken by Eadweard Muybridge, demonstrated graphically for the first time the way that horses actually run.

Right: In navigating hurdles, runners twist their bodies out of symmetrical alignment in order to 'feed' themselves over the hurdle. The extended arm counterbalances the displaced centre of gravity.

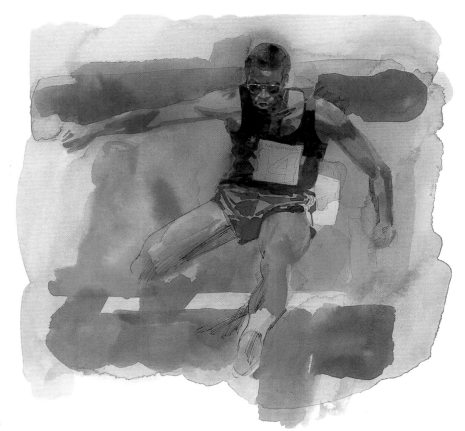

So, gladly accept the help that photography offers. Video, too, can tell you a great deal about what happens faster than the eye can follow. Slow, frame-by-frame playback on video of a high-speed action reproduces with ease what Muybridge arrived at with such hard work and ingenuity.

For this project, look for pictures in which the camera has been swung to keep pace with a fast-moving figure. Pictures shot in this way hold the figure in sharp focus, but, because the camera is moving, the still background is recorded as a series of more or less blurred images, depending on how fast the figure is moving past it.

BLURRED MOVEMENT

46

A NOTHER WAY to suggest movement is to take a further leaf out of photography's book and capture the blur of the moving image. Even with non-professional equipment it is now possible to take photographs with exposures as brief as 1/2000th of a second which can record sharp images of moving objects. Specialized cameras and film can even capture such momentary instants as the impact of a rifle bullet on a target or the crown-shaped pattern of droplets that are created by another droplet falling into milk. Fascinating though these images are, they contain little or no impression of the movement of which they are a split-second part.

By contrast, early photographs and emulsions could only record sharp images if their subjects remained absolutely still: people who moved were recorded as a blurred image. Similarly, if you now take a photograph of a moving figure using too slow a shutter speed to freeze the action, the image will be soft and smudged in the direction of the movement. It may not be considered by some to be a technically good photograph but it may very well give a marvellous impression of a figure in motion. As in the last project, you will also find single frames isolated from video recordings to be useful reference for these blurred images – even though the continuously projected film looks sharp, some of the frames will show blurred elements where the action is too rapid for the camera to follow.

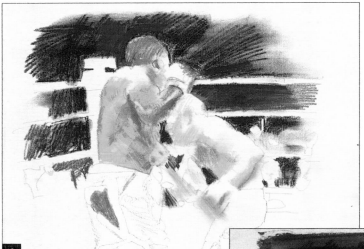

1. The crisp photograph which provided reference for this drawing needed some 'editing' to make a lively image. A plan of the drawing was laid out in line with coloured pencil. Then the main dark tones were applied, still with coloured pencil, which could be smudged by hand.

2. Next, gouache paint was applied, at this stage mostly transparent. The paint provides crisp edges to contrast with the blur of the smudged pencil.

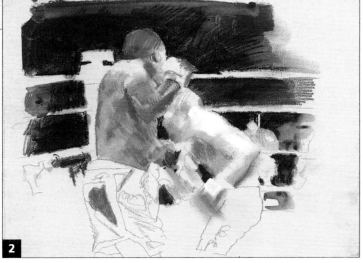

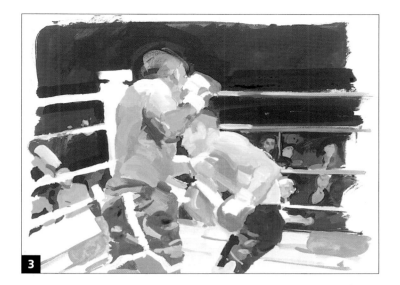

Allow these images to suggest ways that you can give a sensation of active movement to your drawings of moving figures – adapt them freely, push the colour around, smudge it with your fingers, and look out for happy accidents.

3. One of the aspects of a boxing match which makes apparent the swift movement is the physical bulk of the contestants. Here, the simple areas of colour elucidate the slab-sidedness of the figures.

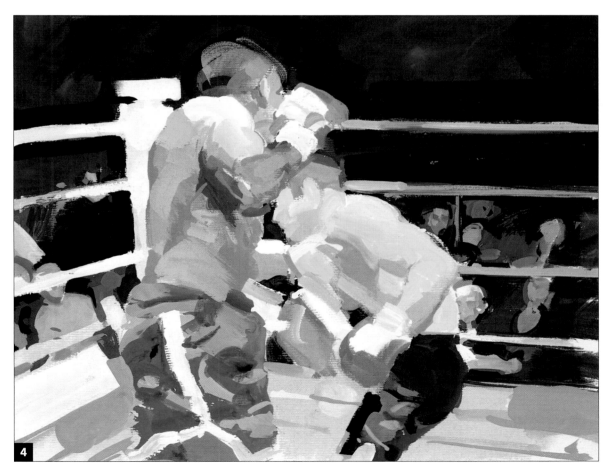

4. The combination of optical tricks, like the blur of the ducking boxer's right glove and around the head of the other boxer contrasting with the solidity of their structure, succeeds in creating the sense of rapid movement, and of a moment not frozen, but continuing in time.

SEQUENCE MOVEMENT

*F*OR THIS project we are returning to the studio and the services of a model. It comprises two slightly different exercises. In the first you ask your model to perform a repetitive movement, such as walking slowly backwards and forwards across your eyeline. You then concentrate on one instant of this movement and each time it occurs you draw one small segment of the figure. It may be just an angle of a leg or a single pivot point, but each time the movement passes your chosen point of view, another piece of the jigsaw is added. Eventually you will have a complete drawing of one instant of the action.

The second exercise is an extension of the first, in that you should attempt to make a series of drawings of successive moments in the action. Ask your model to try a few sequences of movement that progress from one position to another and choose one which can be halted at intermediate stages without too much discomfort. Choose a colour to work with, then draw the first position. It is best to keep the drawing mainly as an outline; too much tone will make the composite image rather confused. When you are happy with the first drawing, ask your model to move a little way to the next stage position. Because

the pose is transitional, it will probably be difficult to maintain, so draw as quickly as you can. Use a different colour, draw over the previous image and record the parts of the figure which have changed. Repeat the process with two or three different colours until you reach the final position – any more outlines than this are likely to be too confusing. You should end up with a composite image which suggests the actual motion of the action.

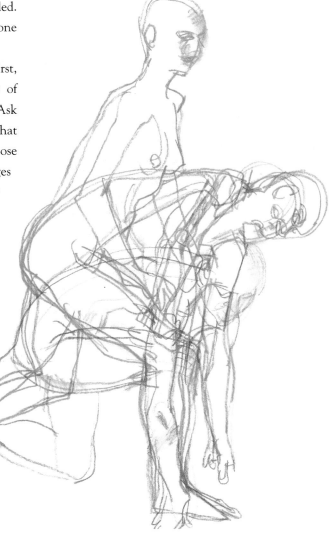

This drawing shows three transitional phases of a model stepping forward and twisting into a crouch. Look not only for aspects that change, but for parts of the form that do not. Here, the feet remain in the same place, and the forward lower leg moves only a little, but the movement of the shoulders traces a wide arc.

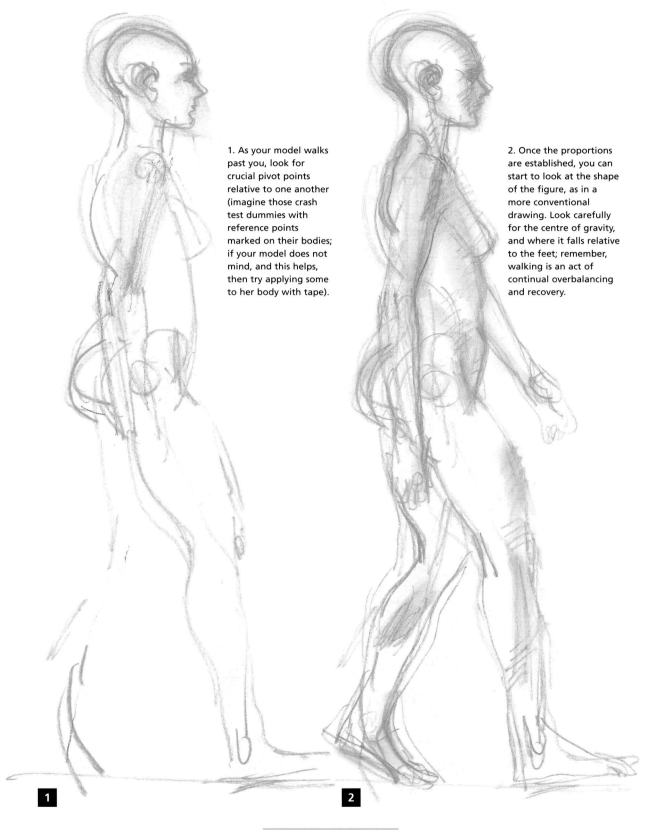

1. As your model walks past you, look for crucial pivot points relative to one another (imagine those crash test dummies with reference points marked on their bodies; if your model does not mind, and this helps, then try applying some to her body with tape).

2. Once the proportions are established, you can start to look at the shape of the figure, as in a more conventional drawing. Look carefully for the centre of gravity, and where it falls relative to the feet; remember, walking is an act of continual overbalancing and recovery.

1

2

Composition

*T*HROUGHOUT THE book so far, we have been imploring you to concentrate your efforts on the process of looking and drawing, and not to be too concerned about what you actually produce. Ultimately, though, the aim is to use your drawing skills to make complete and considered images, and the appearance of your drawing is greatly affected by the relationship that it has with the edges of the drawing surface. If that sounds a little obscure, we mean the layout of the work on the page – its composition.

Visual composition is a huge subject with its own rich library of literature, which we could not hope usefully to summarize here. It was a topic of paramount importance to Renaissance artists, who developed incredibly complex mathematical

The emphasis in this image can be changed completely by varying the placement of the figure in the frame. In the original drawing, the figure was placed centrally. The drawing was made fundamentally as a study of form, and little consideration was given to its composition. If the frame is tall, however, and the figure dropped to the bottom edge, the attitude of the figure seems contemplative. Instead of the form of the model's back, our attention is focused on the empty space into which he is gazing, which we interpret as receding into the distance. Reducing the figure's size in a squarer canvas implies isolation and introspection, and a close crop into the drawing concentrates attention on the surface form. The shape of your drawing area, and the layout of the drawing within it, will always influence the eventual image, so experimentation is essential.

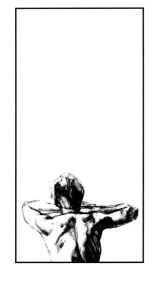

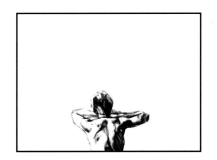

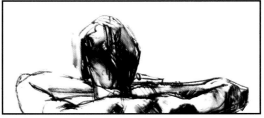

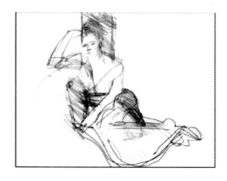

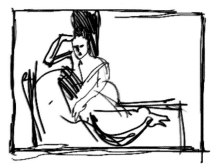

A simple arrangement such as this may be used to explore the varying results of different compositions. Set up your model in a similar pose, but before you embark on a large drawing, make a number of 'thumbnail' sketches. The original, most obvious, composition is balanced and tied to the edge of the frame by the large structure behind the model. A portrait orientation of the paper shifts the focus onto the model's face. This might seem to be stating the obvious, but look back to the landscape format and see how it is dominated by the reclining posture. A square frame, which is generally considered to be 'difficult', immediately introduces a sense of unease, while nevertheless creating a striking composition. If you make as many thumbnails as you can, you may find that your final composition is far more interesting than that which you might have chosen originally.

theories to explain supposedly perfect or divine rules of composition, such as the Golden Section, of which more later. Though research in this area is fascinating, it is not essential, as the best judge of composition is your own sensitive eye. You may have seen artists using viewers, decidedly low-tech instruments made from two pieces of L-shaped card. Often dismissed as amateurish, these are in fact surprisingly useful for making a decision about how to frame your subject on the page. The accepted standard of a rectangle as being the correct shape for a picture is one only of practical convenience; if you pause to think about it, it seems odd in all other respects, given that the view you actually have of the world is closer to an attenuated ellipse. Be that as it may, unless you have a sheet of paper of endless dimensions, your drawings will be intimately and subtly related to the edges of the surface.

The thumbnail sketch is of particular relevance here. This is a small (roughly five to ten centimetres square) plan of your drawing, of which you can make many versions, dealing specifically with the relative proportion and position of light and dark areas in your drawing. This project is an investigation into the different results that can be achieved by varying the composition of one pose.

COGNITION

T IS NOT only the arrangement of light and dark masses on the page that should be considered when composing your drawings. There are more subtle processes at work, which control how we are influenced by an image. One of the least obvious but most important of these is culturally derived from the basic method of reading and writing. In Western culture, our writing is always designed to be read from left to right; therefore our minds are trained to scan an image the same way. Filmmakers exploit this, and generally show people walking from left to right across the screen, as movement in the other direction can seem unsettling, even though you were probably never aware of it.

People of other cultures that adopt a different reading system, say from right to left or bottom to top, will consequently react differently. The way that an unwitting viewer's eye travels around an image can be fairly precisely controlled by the artist: lines and long narrow objects draw the eye along them, and if they are directed out of the image completely, then the eye will follow. The most comfortable arrangement for an observer is one that can be read from left to right and top to bottom, and that generally allows the gaze to settle in the centre. This is not to say that it is necessarily desirable; just that the level of tension and unease induced by viewing a drawing is controllable.

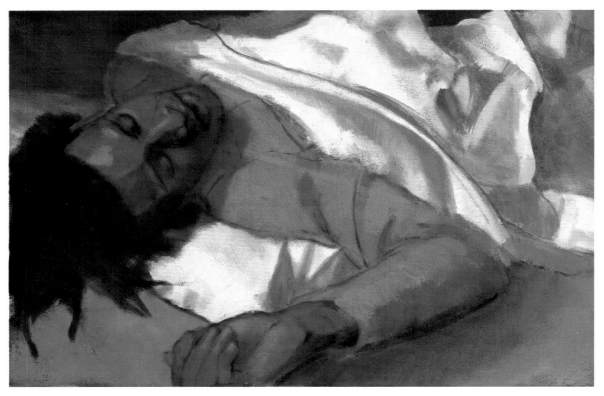

Above: The dominant 'top-left to bottom-right' shapes in this painting create a comfortable composition which matches the mood of the comfortably sleeping subject that it depicts.

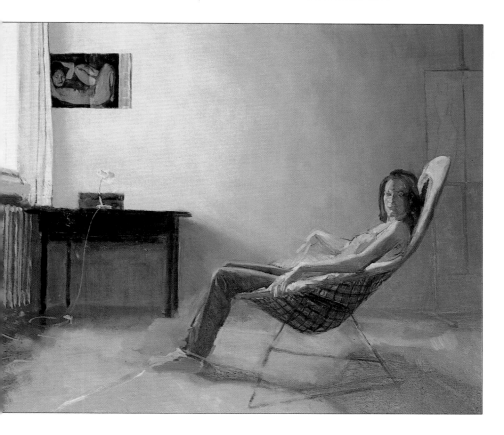

Left: The lightfall in this painting encourages the viewer's eye to move across it from left to right. The dark shapes around the window prevent the painting from 'falling over' to the right, and the cropped edge of the easel in the darkness introduces a little note of discord to an otherwise balanced image.

Other, more universally recognized compositional phenomena are related to our propensity to see objects where there are none, and to seek balance in them. A simple, nondescript, dark shape atop another will appear to be supported against gravity; shift the shapes, as if they were real, so that the structure would collapse, and an immediate tension, almost a desire to move them back into balance, is felt. Without even considering the actual balance of your figures, you can use these principles to adjust the effect of your drawings, simply by the arrangement of lines and dark areas.

Right: Try cutting out some shapes similar to this from paper, and arranging them within a rectangle cut out of another piece. In these diagrams, all of the images on the left are 'uncomfortable', and those on the right are 'balanced'. When treated this simply, it can easily be seen how shapes appear to stack up as if they were actual objects. Also, when shapes touch the edge of an image, they create points to which the eye is irresistibly drawn. The diagram at the bottom left implies that most of the image is cropped from the frame; in fact, the two shapes are present almost in their entirety.

119

FURTHER THEORY

PROJECT 50

*H*AVING TOLD you that an understanding of sophisticated compositional theory is not necessary, here is a project about sophisticated compositional theory! We maintain that these principles are not essential knowledge; however, especially for those of you with a mathematical bent, some investigation into these areas is interesting and worthwhile.

The Golden Section has developed an almost religious significance over the millennia, since its development by Ancient Greek mathematicians. It is simply a proportion – a ratio between two parts. Its definition is this: the second portion is to the first, as the first portion is to the whole. It is this 'self-similarity' which appeals to our innate sense of symmetry and regularity. Among the greatest groups of visual images and motifs that science and computers have given us is fractal geometry, which is a branch of modern chaos theory. Its defining characteristic is also self-similarity, across all scales. The principle of the Golden Section has probably been employed more by architecture than any other profession, but painters, particularly during the Renaissance, also used it to inform their compositions. A 'Golden Rectangle' was defined in which the shorter side is to the longer, as the longer side is to the total of both added together. Important motifs in a painting, such as the face of a religious icon, would be aligned with the Golden Section. If both sides of a rectangle are sectioned, then the point at which the two sections cross assumes particular importance.

In this image, it is the eyes which fall in line with the two Golden Sections. The eyes are the focal point of a portrait, and they are often placed in the most significant place.

Here, the eye level, and that of most of the heads of the figures, lies on the horizontal section. Both frames of the doorway also align with the vertical sections.

FINDING THE GOLDEN SECTION

1 To construct a Golden Rectangle

a · b · c

2 To find the Golden Section of any rectangle

a · b · c

3 To find the 'hot spot' (the intersection of two sections)

a · b · c

In each case, first draw pink, then blue, then green

1. To make a Golden Rectangle, draw a square and then mark a point halfway along one side. Measure the distance from this point to one of the far corners of the square, and then extend this new measurement from the same point, perpendicular to the edge of the square. This will give you the length of the new (long) side.

2. Use this method to find the Golden Sections of a rectangle. Measure half-way along one side, then mark this distance on one of the sides at right-angles to it. Draw a line from here to the far corner of the original side. Using compasses, draw an arc from the top corner to bisect this new line; then draw an arc around the bottom corner, from this new mark, back to the original side.

3. To find the point where two sections intersect (there are four of these: each side has two sections), just repeat step two, on a shorter side. If these written instructions seem tricky to follow, the drawings are self-explanatory; alternatively, you can multiply the length of one side by 0.618 on a calculator, to give you the correct ratio.

All four sections are shown here. The horizontal sections cleanly contain the wall, and the two vertical sections equally neatly exclude the foreground — except for the gesturing hand. This effectively stresses the long and narrow composition, and places visual importance on the gift, held in the hand of the angel.

CONVENTIONAL COMPOSITION

*I*N THIS context, the term conventional doesn't mean boring; it is used to describe compositions which appear 'settled', and induce little unease in the viewer. As discussed, the Golden Section and other formulae have a bearing on this, but the use of such principles is by no means essential. You need to control two aspects of your drawing: the arrangement of light and dark shapes, and the location and treatment of key elements of the subject. In the case of a portrait, these are the face and its features. In the drawing on this page, a conventional yet potent device is employed: a light source (a window), within the picture, bathes one side of the face in light, and casts the other into deep shadow. The dark background throws the lit side into the foreground, and allows the viewer to intuit the other, despite the lack of information there. Across the image, the layout is composed of

Right: Even though the actual head in this painting is off-centre, the subject's facial area is centred horizontally, and just above the centre vertically, which is visually the most comfortable location. The viewer's eye is also continually led away from the edges of the frame, and back to the centre of the image. This is controlled by the curl of pattern on the cushion, by the neckline of the shirt, and fundamentally, by the subject's gaze.

broad diagonals which, in contrast to the riskier approach of the following project, tend to lead the viewer's eye back into the centre of the drawing.

Whatever set-up you choose, consider all its aspects. Pay attention not only to the angle and set of the head, but also to the general arrangement of the body, and arms, and hands; and look for bulky shapes in the background, whether they are real, or created by lightfall. Make good use of thumbnail sketches, including, as here, sketches not only of the tonality of the image, but of the underlying direction of its different elements.

The thumbnail on the left indicates the tonal layout of the main drawing: this is, by area, about equally divided between light and dark. The drawing on the right, indicates the main *dynamics* (direction and force of the marks) of the drawing, which are mostly top-left to bottom-right.

Left: Make thumbnails, similar to those above, to establish your composition, without the distraction of details. In this drawing, the strong diagonal emphasis is countered by the solid, dark area behind the subject's head, which also throws her face into the foreground. The sharp division between the lit and shadowed sides of a face is a traditional compositional device, which accentuates the illusion of relief.

123

PROJECT 52 — UNCONVENTIONAL COMPOSITON

*A*S WE HAVE pointed out, compositional rules are not strict regulations so much as established principles. Treat this project as an example, rather than as something to duplicate. The object is to try to subvert some of the more obvious compositional codes, but still to make a balanced and striking image. The presence of a person introduces its own concerns to the composition of an image, beyond the simple arrangements of light and dark masses.

We expect a face, when in view, to be the centre of attention – the development of the Golden Section is testimony to this – and we are led by the sightline of a person in a picture. Therefore if somebody is looking out towards the edges of the

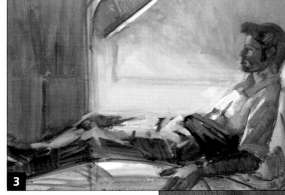

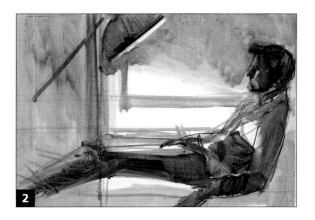

1. Before even the broad tonal areas, the main compositional axes are established. The strong vertical division contrasts with the elegant curve of the figure.

2. Now the actual form of the figure receives some attention, along with the lamp, which is crucial to the composition. It constitutes a sharp diagonal, which contrasts with the rest of the image.

3. The strong tonal contrast adds further simple shapes – the softly rounded lightfall on the back wall. Also, as the head is pushed so far to the right of the picture, the light allows for a distinct profile of the face to be established, which 'pulls' it back in to the picture.

4. As with any drawing, as you near the end, look back over the whole image with fresh eyes. In this case, it seemed that the main change should be in the contrast between the lit and shadowed areas of wall.

image, our eyes will instinctively follow theirs to seek a spot outside the frame; conversely, if they are looking into the picture, then we will too.

In this painting, even though the model's head is pushed to the far right of the picture, his long gaze across it directs the viewer's eye back in, which stabilizes the overall composition. Also, the central pool of light may appear to be in the wrong place, as his head is cast into shadow. In this case, it came about by accident, as the model was initially dazzled by the bright light in his eyes, and when it was shifted down we found that we much preferred the new composition. Because a face has so much significance to us, it can be almost hidden in darkness in an image, yet still be the dominant feature. Experiment with this as you set up your own images.

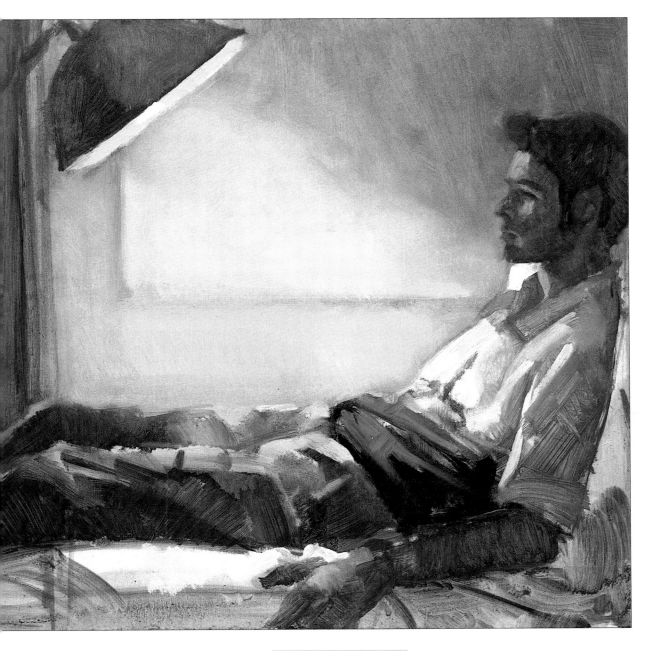

Lighting

NATURAL LIGHT

*I*F WE ARE to see something, then it must be lit. The source of this light may be artificial – to be examined in the next project – or it may be natural, which virtually always means the Sun. The colour and strength of light that we perceive is highly dependent on the path that it took through the atmosphere before reaching us. Light is scattered by dust particles in the atmosphere, so more particles, or denser atmosphere, means more diffuse light, and therefore less sharp shadows. To some extent, this effect can be seen as you travel toward the poles from the equator, because the increasingly oblique angle between the Earth's surface and the Sun demands that the Sun's rays must travel through a great deal more atmosphere than they do to reach the equatorial regions. In reality, the lack of industrial pollution in the skies of the more sparsely inhabited polar regions more than makes up for this physical property.

A similar principle has long been referred to, in the northern hemisphere, as northern light. This is not light that originates from the north – it is sunlight, after all – but light which has been reflected back through the atmosphere, so that from, for instance, a north-facing window, all of the light that is received is indirect. The fact that the light has effectively turned a corner indicates that it is already about as scrambled as it can get, and the result, on a clear day, can be exquisite subtlety in the resulting shadows. In this project, then, it is this delicate light which is to be investigated.

1. For this project, oil paints were used, because they are particularly good for carefully modulating closely related tonal values. A dark ground (oiled stencil paper, in fact) allowed the painting to begin with light, opaque colours, a practice which may seem at odds with the previously recommended method. The qualities of this light, however, suggest the adjustment.

2. Even though most of the image is composed of similar, pale tones, there will be some very dark areas, and it is important that they should be observed carefully, if the painting is not to appear 'bleached out'. In this case, the shadow under the left arm of the chair is very dark, even though the cloth that covers it is known to be light-coloured.

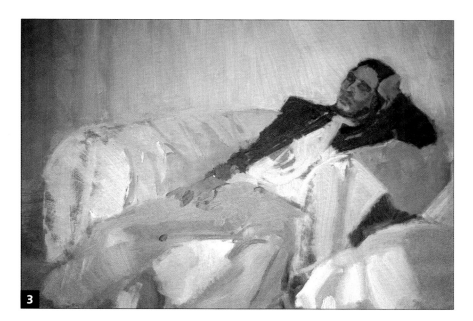

3. When the entire surface has been covered, look through squinted eyes, and try to see if there are any main tonal areas which seem wrong (there will be). Here, the knowledge that the wall is painted white proved too hard to resist, and subsequently this part of the painting had to be darkened.

4. It is, in some ways, the dark areas which will make this kind of subject, as they provide the visual 'anchors' for the eye. But, primarily, it is the subtlety, not just of tone but of hue, which this clear light produces, that is most interesting.

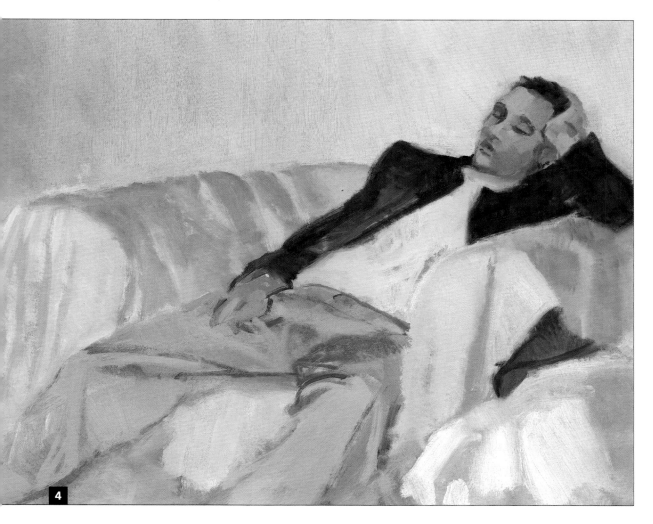

ARTIFICIAL LIGHT

PROJECT 54

\mathcal{A}RTIFICIAL LIGHT can be configured to provide virtually any illumination characteristics that may be imagined. We use the term to describe any light source other than the Sun and in most cases it refers to the tungsten lighting that we use domestically, the chief characteristic of which is its rather yellow tinge, and to fluorescent light tubes, which give a more generalized light and are bluer or even pinkish by comparison.

With a combination of movable spotlights and variable intensity overhead lighting, any lighting set-up can be achieved and precisely controlled. But even with just a single light source, it is possible to realize dramatic effects. For example, a strong directional light placed directly above or immediately to either side of your model will cast shadows caused by the smallest variations in the surface form, the same way that the grain in paper is revealed by lighting it from the edge.

These shadows have great creative potential. Dramatic and surprising shadowy shapes can be cast that completely change the appearance of the figure. Just as you can use the fall of light to clarify the form, so you can also use it creatively to confuse the eye. Placing the light low down, even perhaps on the floor, creates an 'upside down' pattern of light on the model, akin to footlights in the theatre, so that shadows are cast upwards and the underside of forms are illuminated in an unexpected way.

Obtaining sufficient light to see your work is one practical difficulty that occurs when a single light source is directed at the model. Another lamp introduced to solve this must be carefully shaded or of sufficiently low wattage to avoid disturbance of the principal light on your model. Also you will find that colours applied under tungsten light will look different when viewed in daylight – fluorescent or special blue daylight bulbs minimize this effect.

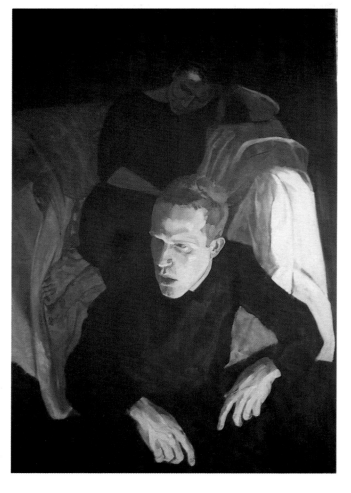

In this painting, the low light accentuates the intimacy established between the viewer and the subjects. It also casts some unusual shadows on the foreground face; the eyesocket, for example, is set well behind the cheekbone, and therefore creates a pool of shadow.

1. A single light source will create very crisp edges of light and dark areas across a figure. Try to concentrate on how these new shapes fall across the form, just as much as on the actual edges of the figure.

2. Even with only one source, enough light will be reflected back into the dark areas for significant tonal variation to occur. Roughly painting in the background helps to establish the values across the figure as well.

3. In this set-up, there was enough reflected light to concentrate on the colour of the dark areas. Let yourself be persuaded by your eyes; if you see blue, then let it be more blue, etc. Be conscious, however, of keeping the relative tones accurate.

4. In this painting, it was necessary to complete the dark background, to convey the dramatic tonal variation that the low light produced. It is perfectly acceptable to sharpen edges of lit areas creatively where in fact they may be softer, because this is the chief characteristic of artificial light.

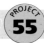

SUNLIGHT THROUGH A WINDOW

\mathcal{D}RAWING OR painting a subject directly lit by the Sun has one inherent problem: the areas of light and shade are never still for long. If you are drawing from life, this means that you must work very quickly; perhaps, if it is practicable, return to the subject at the same time on different days. A more practical solution to the problem, although with its own hazards, is to record the lighting conditions by taking some photographs. The danger comes from the temptation to copy the photos slavishly – a pointless exercise as you might just as well accept the photographic image if your drawing adds nothing to it.

However, the pattern of cast shadows and bright highlights on a sunlit figure can be so exciting that it is worth the trouble to capture it. The girl pictured here is posed by the studio window where she interrupts the fall of sunlight, and where the window uprights throw sharp-edged shadows across her legs and torso, in places reinforcing the form, in others making it intriguingly ambiguous.

A further element is added by the combination of transparency and reflectivity of the window glass itself. See how the glimpse of the foliage outside the window combines with the reflection in the glass of the model's profile.

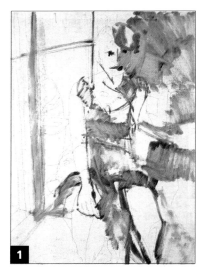

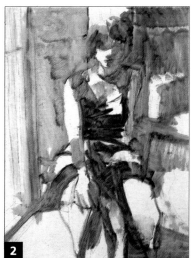

1–3. As this is fundamentally a tonal subject, the first step is quickly to organize the main broad tonal areas. Particularly look at the way that the shadows cut across the figure.

4–5. Try to keep to transparent colour when working on the darkest areas. As discussed in Section 3, this polarity between clear and opaque colour strengthens the illusion of lightfall.

6–7. Of particular interest here is the reflection of the figure in the window. Also, the introduction of opaque paint into the lit areas allows the solid form of the model's shoulders and collarbones to be investigated.

8–9. Towards the end, sit back and judge the overall tonal range. This image relies on the contrast between the bright directly lit areas, as on the model herself, and the more subtle reflected areas, such as the window and the figurine.

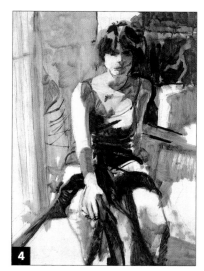

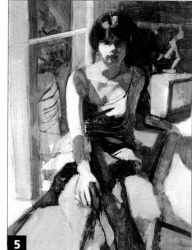

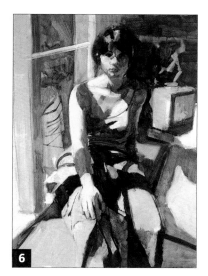

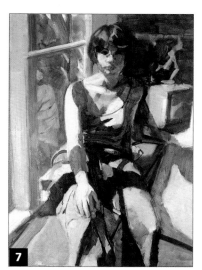

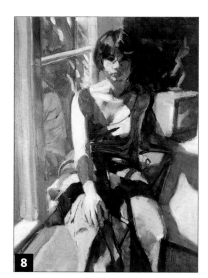

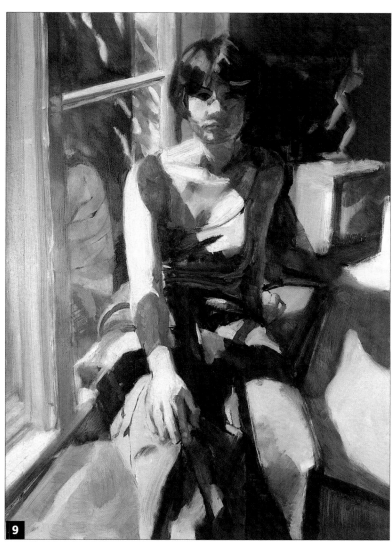

SUNLIGHT OUTDOORS

PROJECT 56

*A*LTHOUGH RATHER more difficult to set up and beset with such problems as continually changing light direction, dazzle from the drawing surface, not to mention the effect of heat and Sun on your model, drawing outside in sunlight is wonderfully satisfying when it goes well.

1. Given the unforgiving nature of watercolour, a fairly detailed pencil drawing was made first, so that crucial small areas could be located. Then the first large washes to establish the main shapes were applied.

2. Remember that your first marks with watercolour are also your final ones, so be precise about where you lay dark washes. This powerful outdoor sunlight is identified by strongly lit areas, which must remain the white of the paper.

3. Pay attention to the colours that occur in the darkest areas. Bright sunlight, and surfaces as reflective as these brass instruments, together produce some of the richest and strongest hues.

4. The combination also results in dazzling complexity. The simplicity of the foremost musician's jacket is in distinct contrast to the cascade of reflections and highlights further back.

As with the previous project, sunlight through a window, you will need to work quickly if you are to capture the varying light and shade in one session. For a directly observed colour sketch of a single figure, oil paint has certain advantages. It stays wet and malleable and allows you to cover large areas and change them easily. Very quick notes can be made in watercolour too, but the time involved in creating the more considered multiple wash approach described earlier will make it very difficult for you to keep pace with the constantly moving Sun. Here again the camera can come to the rescue, especially when it comes to recording the more complex figure group compositions.

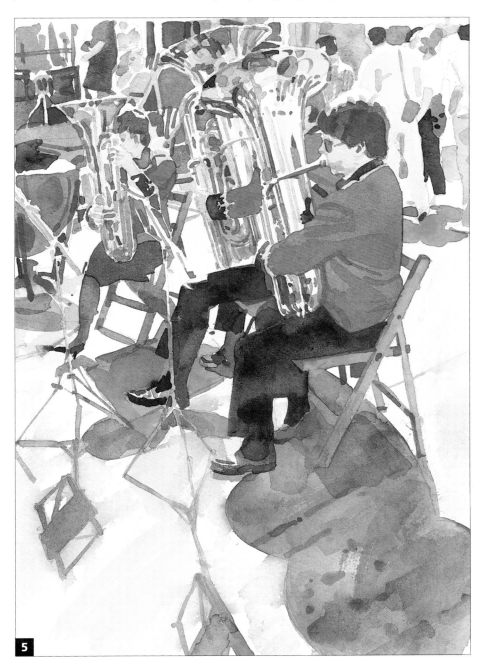

5. Most of this painting is almost totally abstract. The presence of the central figure allows the rest of the image to be understood. Let yourself be taken by the abstract dappled light as it appears: if your observation is honest, the result will be a lively sense of shifting light.

5

CONTRE JOUR

*I*N PHOTOGRAPHY, recording an image of something that is lit only from behind is a notorious problem. Countless holiday photographs of dazzling light-diffused skies, disappointingly inhabited by completely black silhouettes in the foreground, are testimony to this. The problem is that the camera registers the bright sunlight and effectively squints to block it out – impairing its ability to record anything else. Your eyes do the same thing. If a person is backlit and receiving little light from in front, for instance against a window on a bright day, while the variation of tones across them might actually be no less than if they were standing against a wall, in comparison with the bright light outside, they appear silhouetted. This presents you with a choice about how to approach a drawing of such a situation. The Impressionist, or plein-air, approach would have been: paint as you see it! Meaning, if you are blinded a little by your view, then let your artwork reflect that, and draw the silhouettes as they appear. Alternatively, you can try to rationalize the view, and aim for correct exposure. This means looking closely at the tonal range in the figure, and reproducing it more faithfully. However, the mind is inclined to overdo this, and you need to make sure that the lit and shadowed areas are different enough that the overall appearance is not overcast. The success of these kind of images, whatever the approach, is dependent on careful modulation of the two very different sets of tone.

Above: These are the two different ways in which you may observe your subject. In the top drawing, the background is bleached out, but the features of the figure are visible; in the lower drawing, the background is visible – but the figure is silhouetted.

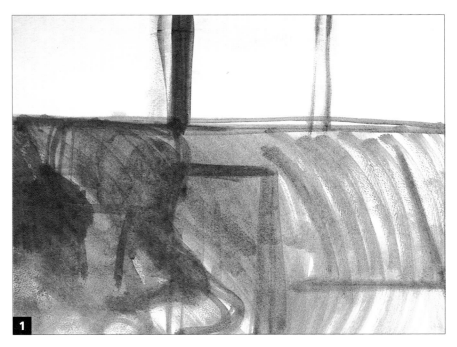

1. Any medium that allows you to cover broad areas quickly is desirable here, as it is important that you should establish the tonal extremes right from the start. Only the beginnings of a figure can be seen, but at this stage, that is unimportant.

2. Try not to be too seduced into lightening the tones of the figure. Some fairly sharp highlights can be seen here, but the rest is still relatively dark. Also, look carefully at the colours of anything outside the window; even though you know them to be dark green trees, they may appear much lighter.

3. Be prepared to stop your work earlier than you might with a different subject. The temptation to 'even-up' the tones is always very strong, and the lighting is such that the effect can be achieved very quickly.

Character

In this last section we invite you to let yourself go a little – to allow the establishment of human character to take priority over the appearance of solidity and form. The main emphasis should be on those elements of a face and figure which make up an individual. The figure has so far been considered as a form, or a collection of forms linked mechanically, which is interacting in certain ways with its environment. That we have chosen this emphasis does not mean that the process of drawing people ends here; in some ways, this is only the beginning. The fundamental drive to draw, in most people, is generated by a desire to distinguish, and communicate, the aspects of a person which make them unique: to show their character.

Methods of communicating character are virtually impossible to define. We previously mentioned that a likeness would come when you least expect it, and the same applies here: the physical appearance of a person, and their personality, are intimately related. Your best equipment is a relationship with the person whom you are drawing, so try whenever possible to draw your family and friends. Children are special cases in a structural sense, in that the relative proportions of their bodies are so different from those of adults; also their general inability to stay still presents a challenge.

The dedication of a set of three projects to older people is an acknowledgement of the pleasure that can be had from drawing people who have lived through a great many different experiences.

Children

CRAWLERS AND TODDLERS

*F*ROM THE point of view of trying to draw them, children pose particular difficulties. To younger children, the idea of remaining motionless, so as to be drawn, makes no sense; indeed, if you do manage to cajole them into staying still, the aspect of them which is often most appealing, their endless energy, is lost. It is a good idea, therefore, to try to draw from life.

It is virtually impossible to draw children when they are running around, so engage them if you can in something static. The chaotic changes in attention span that children display are punctuated and defined by periods of deep concentration, and this is when you should grab your chance. It is by no means essential that you finish the drawings; look closely and draw as much as you can, and if the child moves, well, start another drawing. Don't be tempted to 'make up' any bits that you miss if you cannot remember precisely how they looked – this will only weaken your drawings.

The physical proportions of toddlers are clearly different from those of an adult. The head constitutes a far greater proportion of the total body volume, containing as it does a brain working in overdrive. The squat body and limbs, in making the transitions from infant to crawling to walking, never seem to be quite right for the current stage of development. This unsteadiness is often the most interesting aspect of young children, especially when combined with their wanton self-disregard.

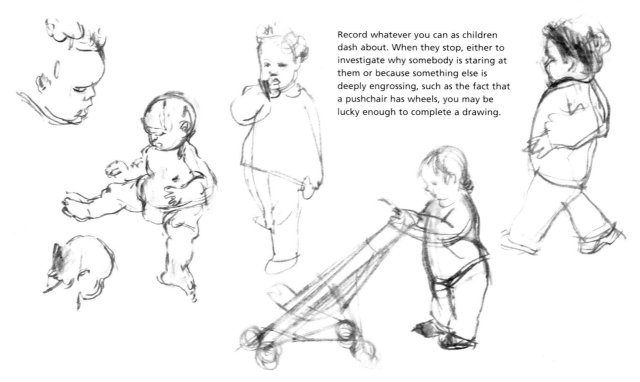

Record whatever you can as children dash about. When they stop, either to investigate why somebody is staring at them or because something else is deeply engrossing, such as the fact that a pushchair has wheels, you may be lucky enough to complete a drawing.

Right: This three-year-old was just old enough to understand about staying still for a drawing. (Artist parents helped here.) Five minutes was all he could manage, however, but this allowed just enough time to gather the bulk of the information.

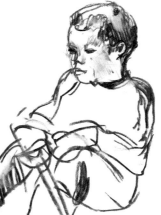

Right: As crawling is a skill which they have not yet mastered, babies tend to stay in one place. Use the method described in the 'Movement' chapter, of waiting for repetitive movement, and drawing whenever the position recurs.

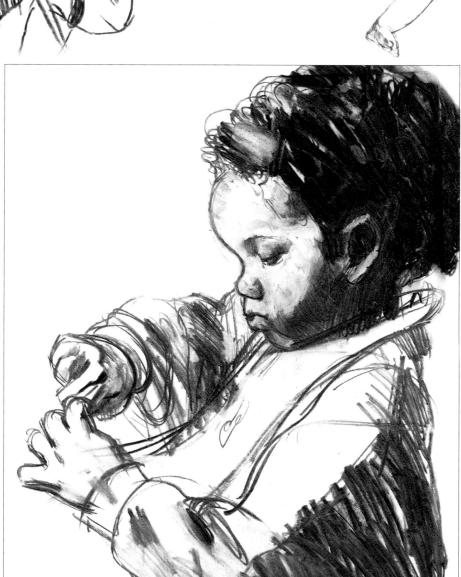

Right: The complete devotion of this little girl to the task of retrieving the last scrap from a yoghurt carton was the main interest here. The large relative head size of toddlers is also accentuated by the sharp profile view.

SLEEPING OR PREOCCUPIED

A FTER THE flurry of speed drawing in the last project, we suggest that you now try some drawings of children who are either asleep or preoccupied, for example by television, so that they will remain still enough for you to make more complete drawings. Other than drawing from photographs, this is probably the only way that you will be able to draw young children in any detail.

Of course there is always the risk that your sleeping model will wake up too early, so it is probably a good idea to take a photograph before you begin drawing, which can be used later to complete the drawing. Which again begs the question: why not just work solely from the photograph? Well, you can of course, but the more you draw from life, the more you will be able to

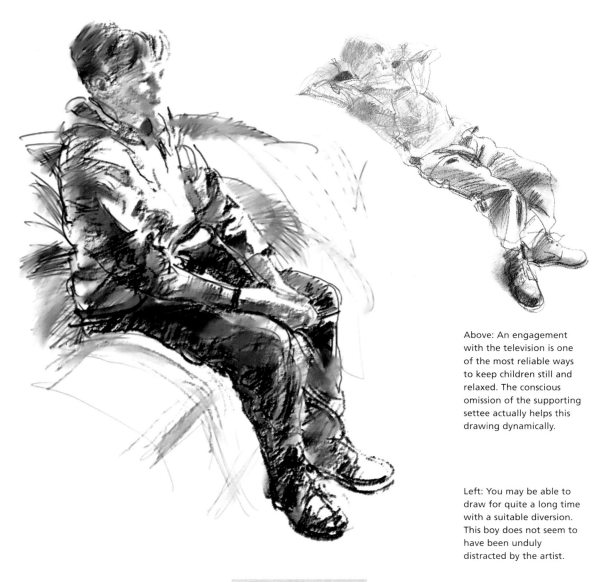

Above: An engagement with the television is one of the most reliable ways to keep children still and relaxed. The conscious omission of the supporting settee actually helps this drawing dynamically.

Left: You may be able to draw for quite a long time with a suitable diversion. This boy does not seem to have been unduly distracted by the artist.

extract from a photograph. If you never draw directly from a model, you will never learn how to translate your three-dimensional vision into the two dimensions of your drawing. A photograph records the fall of light, and that is all it does; you cannot see the volume as you do in life, enabling you to express it by the variety of means that we have discussed in this book.

Only if you have drawn from life many times before will you find that you can look at a photograph, and by remembering how you searched for and discovered the form in the live model, free yourself from slavishly copying the pattern of light and shade displayed there.

Babies and toddlers redefine sleep. The supporting harness only serves to accentuate the careless and complete relaxation of this little girl.

ADOLESCENTS

ADOLESCENTS, JUST like younger children, are full of energy, but by the time they are in their early teen years they can be expected to curb their activities and stay in one position for long enough to be drawn without your having to devise ways of occupying their attention. They may indeed have reached an age when they are interested in your drawing, how you work and what you will make of them. Of course, their awareness may make them shy and diffident, in which case you must be patient, perhaps doing the first drawing as a throw-away to allow them time to relax. If they have natural exuberance, on the other hand, let them express it.

Be ready to encourage children of this age to contribute their own ideas: it may only need a suggestion from you to provoke a flurry of invention. These two young friends in their dance costumes were full of ideas for posing together – the more relaxed positions could be drawn direct, some of the more active ones needed the extra help of a

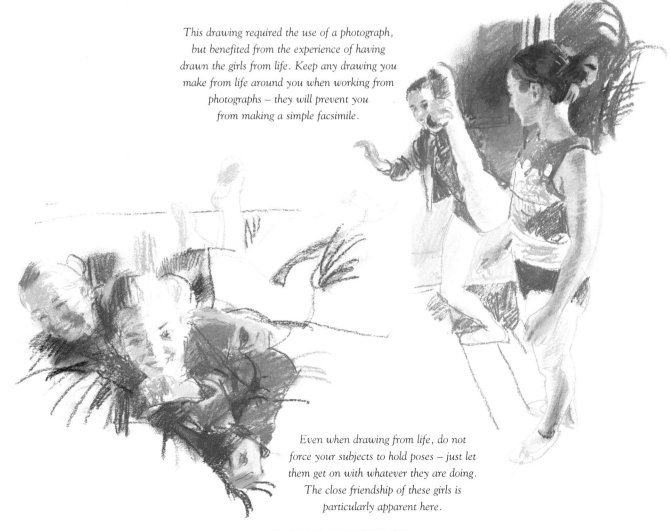

This drawing required the use of a photograph, but benefited from the experience of having drawn the girls from life. Keep any drawing you make from life around you when working from photographs – they will prevent you from making a simple facsimile.

Even when drawing from life, do not force your subjects to hold poses – just let them get on with whatever they are doing. The close friendship of these girls is particularly apparent here.

While dance positions are naturally imitative of adult dancers, you should also take pleasure in the exuberant, unselfconscious type of pose that teenagers will hurl themselves into and which adults would be very unlikely to adopt.

Concentration on a particular activity, a devotion to one thing (which often changes to another with dazzling speed), is characteristic of adolescents. This preoccupation is evident in this drawing.

When drawing two people together, try to treat them as one form, in much the same way as earlier in the book we encouraged you to treat a sitting subject and their chair as one. The kinship will be all the more apparent.

Character and Expression

FINDING THE PERSON

HEN YOU are specifically trying to make drawings that communicate somebody's character, the natural inclination is to seek out somebody whom you judge to be especially characterful. People that display eccentricities in appearance or behaviour may seem particularly interesting as potential subjects, and in all likelihood they would prove to be so.

However, drawings are capable of communicating more than superficial characteristics, and can become subtle but clear reflections of a person's state of mind, of whether somebody is happy or unhappy, distracted or focused. In these cases, your models need not be 'characters', and you must scrutinize them closely and try to reveal their essential nature through your drawings.

So there is no need to seek out special models for this project: all we ask is that you change the emphasis, away from

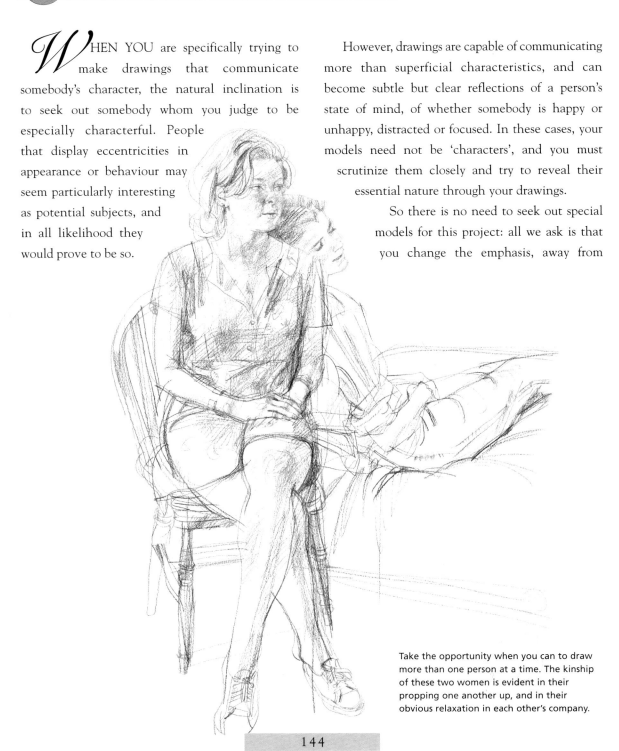

Take the opportunity when you can to draw more than one person at a time. The kinship of these two women is evident in their propping one another up, and in their obvious relaxation in each other's company.

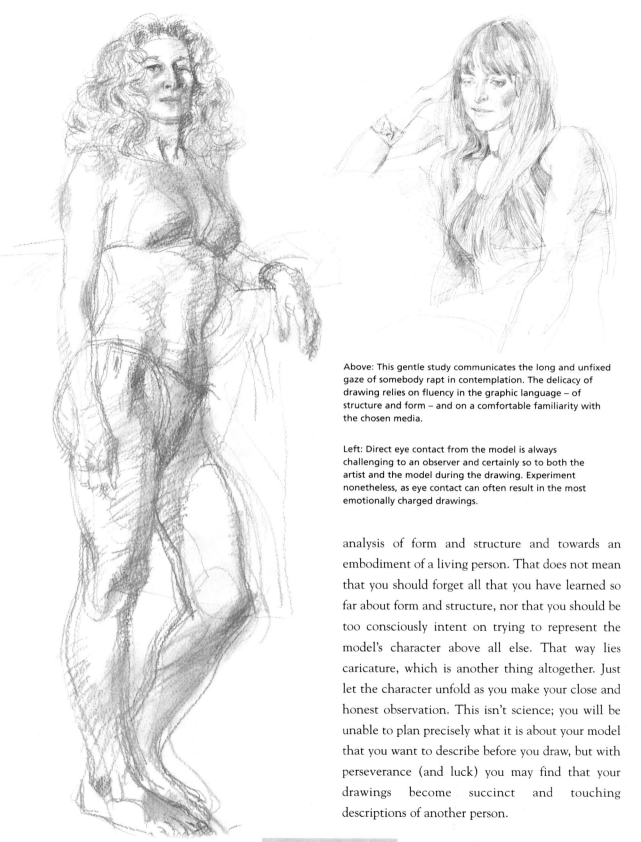

Above: This gentle study communicates the long and unfixed gaze of somebody rapt in contemplation. The delicacy of drawing relies on fluency in the graphic language – of structure and form – and on a comfortable familiarity with the chosen media.

Left: Direct eye contact from the model is always challenging to an observer and certainly so to both the artist and the model during the drawing. Experiment nonetheless, as eye contact can often result in the most emotionally charged drawings.

analysis of form and structure and towards an embodiment of a living person. That does not mean that you should forget all that you have learned so far about form and structure, nor that you should be too consciously intent on trying to represent the model's character above all else. That way lies caricature, which is another thing altogether. Just let the character unfold as you make your close and honest observation. This isn't science; you will be unable to plan precisely what it is about your model that you want to describe before you draw, but with perseverance (and luck) you may find that your drawings become succinct and touching descriptions of another person.

MUSICIAN

*A*FURTHER WAY to express character is to pose your sitter with the tools or paraphernalia of his or her trade or profession. Not all lifestyles can provide such visual clues of course: you really need people who possess manual skills and have used them on a daily basis for some years. If you are lucky, a pose which is special and different will result from the interaction of the two.

As well as handling tools of the trade, your subject may perhaps wear special clothes: a woodworker, for example, with pocketed apron, or an aircraft pilot with uniform or flying jacket, or even a dancer in leg warmers and leotard. It may not be so easy to find craftspeople in specialized clothes as it once was, but once alert to the possibilities, opportunities do occur.

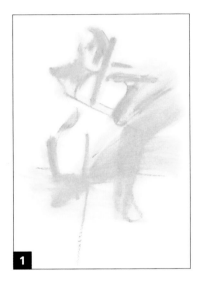

By moving in close to the subject, the foreshortening enhanced the already dramatic shape of the cello. It is important in a situation such as this that you allow the musician actually to play the instrument, so that the resultant facial expression is one of concentration, rather than boredom.

1. Oilbars and a turpsy rag are used to formulate the main thrust of the drawing, retaining as much of the movement as possible.

2. Conté pencils, which work very well over the oily base, are used to refine these shapes, and to locate the subject on the floor. This three-legged stability is fundamental to the drawing.

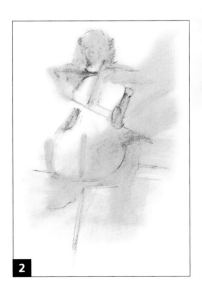

3. As discussed in the movement projects, you must select a specific point in the musician's movement, and draw when she repeatedly returns to it. A good deal of detail can be determined this way, without losing the energy of the pose.

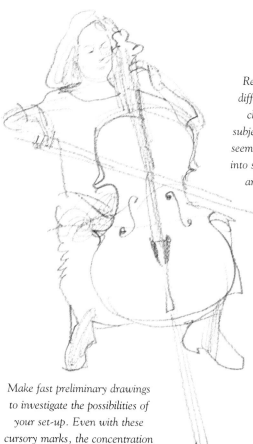

Rest periods offer a different angle on the character of your subjects. The cello now seems to be transformed into something awkward and cumbersome.

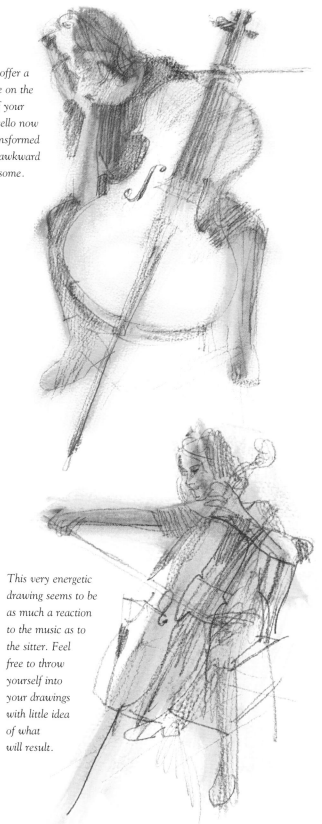

Make fast preliminary drawings to investigate the possibilities of your set-up. Even with these cursory marks, the concentration of the musician is evident.

A musician is ideal for the purpose – the musical instrument itself often has an interesting shape and maybe requires special ways of being held and manipulated. All these elements contribute to the complete composite shape. Our sitter for this project made wonderful shapes with her arms as she bowed the strings of her cello, and even when she rested, the need to support the bulky instrument meant that she maintained the characteristic open-legged posture associated with it.

This very energetic drawing seems to be as much a reaction to the music as to the sitter. Feel free to throw yourself into your drawings with little idea of what will result.

Although, while practising, our sitter wore everyday clothes, we asked her to pose in the type of formal dress in which she would give a musical recital. A musician who plays regularly in an orchestra will probably have some sort of identifying clothing, or even a regulation uniform.

LIKENESS IN LINE

S YOU become more confident in your ability to assess the figure in terms of its form and structure, you can begin to investigate drawing methods in which the emphasis is on the character of the marks that you make. For this project, try to describe your subject using mainly linear marks. This presents two obvious difficulties:

lightfall is tricky to render, and major mistakes are difficult to correct.

In answer to the first, there is no need always to draw in terms of light and shade (if you always did this, you would use no lines at all), and in any case you can vary the weight and hardness of your line in response to the tonal values of your subject. As to

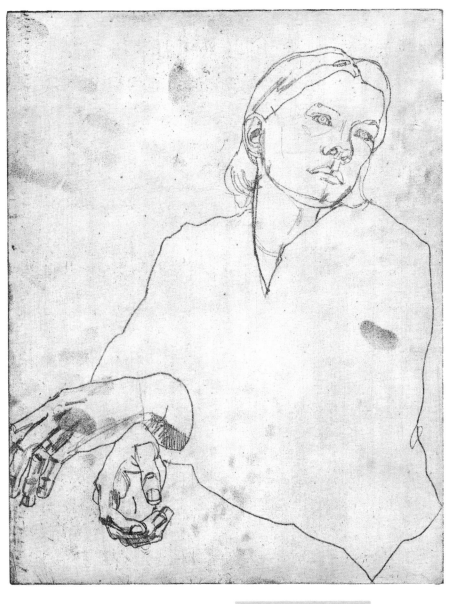

This drawing is actually a steel etching. The traditional etching process offers an extraordinary control and subtlety of line, and it is well worth seeking out a print workshop to experiment with etching and many other print processes. The drawing exhibits a successful contrast between the simplicity of the line describing the body, and the complexity of the head and hands.

the second, this is part of the appeal; where gross misjudgements are a risk, you are forced to concentrate very carefully on the marks that you make, and this close observation will be evident in the final drawing.

The Swiss Expressionist artist Paul Klee famously described the drawing process as 'taking the line for a walk'; with this in mind, feel your way around your subject, letting the line describe any elements of form that seem interesting. It is likely that distortions will develop in your drawing, so keep checking the whole image as before, but if a distortion seems to improve the general attitude of the drawing, then by all means let it stay.

This may be a good time to experiment with 'harder' marks, such as ink pens. Technical pens are limited to just one weight of line, which may be desirable, but traditional dipping pens with flexible nibs produce very varied and characterful marks, which are generally preferable. Pencils offer the advantage of variable density of line, from light grey to solid black.

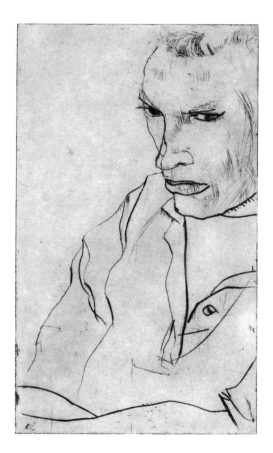

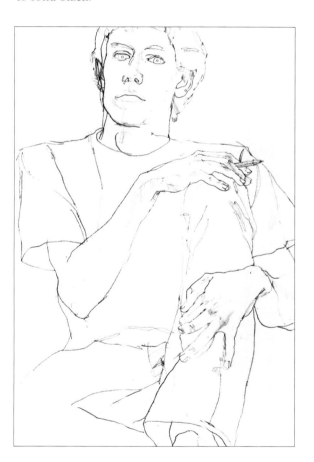

This drawing is made with a variant of etching – drypoint – in which no chemical etch takes place. It is a rather more hit-and-miss process, not least because it is tricky to see what you have already drawn, but its particular advantage is in the huge variety of marks that are possible. Along its length a single line can shift in character from delicate and meandering to harsh and aggressive.

This pencil drawing exemplifies the potential of pencil as a linear and precise medium. Its versatility means that the same instrument used to make a thin black line may also lay down a faint and subtle area of tone. In this case, the tonal marks exist only to elucidate the form – the lightfall is mostly ignored. Take your time over drawings like this, and concentrate on each line.

SPECIAL CLOTHING

*T*HIS PROJECT is an extension of project 63, in which we asked the sitter to pose with an object that had some relevance to his or her life, in that case, a musical instrument. This time, look for models whose accessories and dress tell you something specific about their trade or profession. Not all lifestyles can provide such visual clues of course; you really need people who regularly handle tools of their trade and are required to wear special clothing for utility or protection. The type of objects we have in mind in this context are, for example, the pocketed apron and woodworking tools of a carpenter, the white coat and stethoscope of a doctor, an aircraft pilot's flying jacket, even the leg warmers and leotard of a dancer. It may not be as easy now to find people in specialised clothing as it

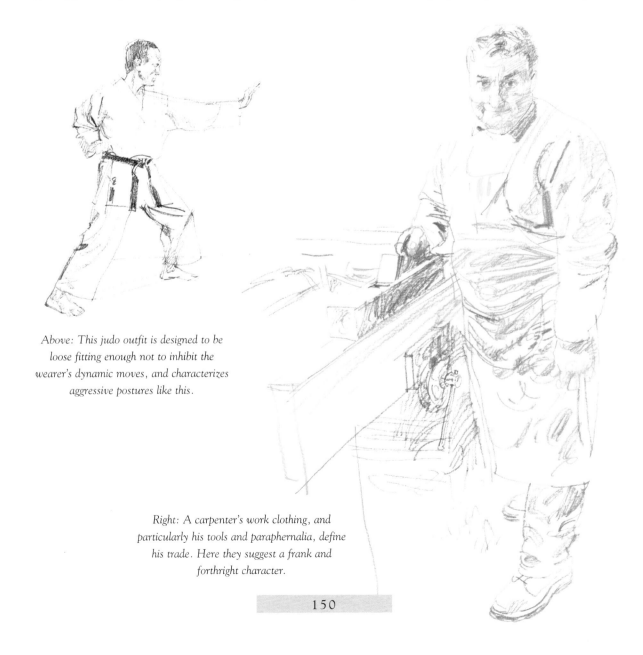

Above: This judo outfit is designed to be loose fitting enough not to inhibit the wearer's dynamic moves, and characterizes aggressive postures like this.

Right: A carpenter's work clothing, and particularly his tools and paraphernalia, define his trade. Here they suggest a frank and forthright character.

was in the past when every craft and trade had its own visual identity, but if you are alert to the possibilities, opportunities do occur.

Alternatively, your subject may wear special clothes specifically to denote their rank or authority or just to make them and their function immediately recognizable – traffic wardens, gas and electricity inspectors, doormen etc., are obvious examples of the latter. Members of the armed forces may wear battledress or ceremonial uniform and there are many other special costumes and insignia of office that are habitually worn in professional life.

Although not perhaps representing a character-defining lifestyle, the type of fancy dress chosen for a party may be quite revealing of a person's extrovert tendencies or otherwise – and in any case such a costume is likely to be very enjoyable to draw.

Above: Young children invariably choose the most suitable clothes for playing in the park – in this case the clearly sensible angel wings and tiara ensemble! The defining charateristic is the completely sincere demeanour.

Left: An admiral's full uniform displays the high status of such a position, and offers a chance to continue the tradition of classical court painting. In contrast to the severity of the uniform, the subject seems particularly relaxed, and these sorts of visible contradictions deserve exploring.

Older People

GENERAL

*H*ABITUAL EXPRESSIONS become rather more fixed in old age; lines and furrows deepen, skin texture and colour may change in various ways. It is never possible to predict exactly what changes to shape and form will characterize the face and figure of an older person. At one extreme you may see weight gain run riot, at the other, weight loss to the point of emaciation can occur. Actors often caricature the movements of age as bowed down and shuffling but the elderly, especially nowadays, are just as likely to stand ramrod straight and to stride out purposefully.

We have only allocated three projects to drawing the elderly but you should not feel limited

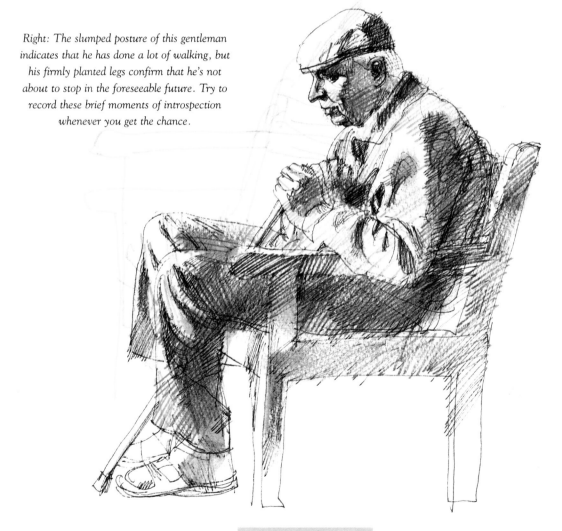

Right: The slumped posture of this gentleman indicates that he has done a lot of walking, but his firmly planted legs confirm that he's not about to stop in the foreseeable future. Try to record these brief moments of introspection whenever you get the chance.

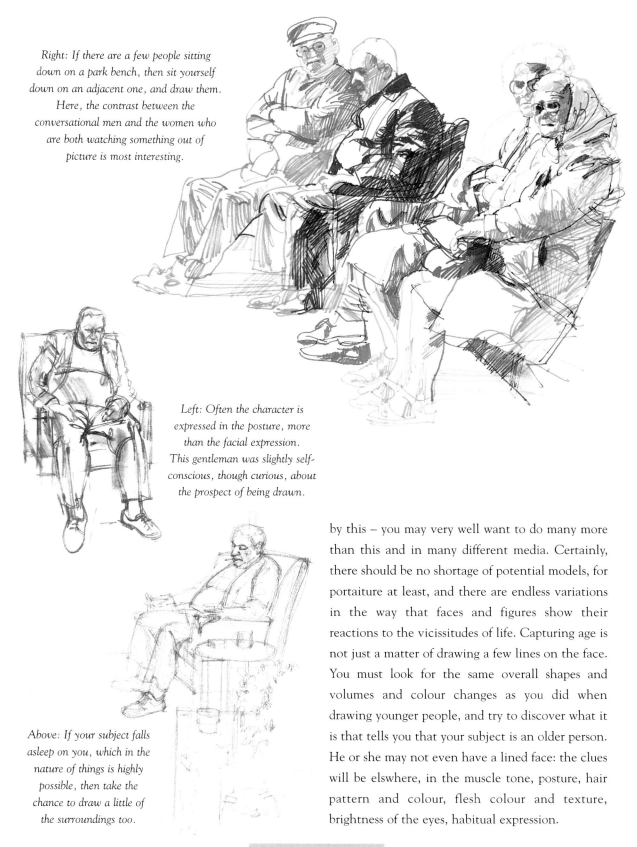

Right: If there are a few people sitting down on a park bench, then sit yourself down on an adjacent one, and draw them. Here, the contrast between the conversational men and the women who are both watching something out of picture is most interesting.

Left: Often the character is expressed in the posture, more than the facial expression. This gentleman was slightly self-conscious, though curious, about the prospect of being drawn.

Above: If your subject falls asleep on you, which in the nature of things is highly possible, then take the chance to draw a little of the surroundings too.

by this – you may very well want to do many more than this and in many different media. Certainly, there should be no shortage of potential models, for portaiture at least, and there are endless variations in the way that faces and figures show their reactions to the vicissitudes of life. Capturing age is not just a matter of drawing a few lines on the face. You must look for the same overall shapes and volumes and colour changes as you did when drawing younger people, and try to discover what it is that tells you that your subject is an older person. He or she may not even have a lined face: the clues will be elswhere, in the muscle tone, posture, hair pattern and colour, flesh colour and texture, brightness of the eyes, habitual expression.

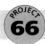

ELDERLY LADY

*A*LTHOUGH IT is often unwise to generalize, older people are more likely to tolerate (or even enjoy) sitting still for you, than will the restless young. As ever though, be careful to ensure your model's comfort – it is important to remember that older people may feel the cold more acutely and are likely to need refreshment and bathroom breaks a little more frequently than models of a younger generation do.

You may be fortunate enough to have relatives of the appropriate age who are happy to pose for you, but if not, an approach to a residential home for the elderly will often be successful in securing a willing model or two. The lady who posed for this project was 88 years of age at the time that she was asked to sit for a drawing and is probably now past her 90th birthday, but, as I am sure you can see in her face, she had a bright, optimistic attitude to life. She was also interesting to talk to and her smile was natural to the point of almost never leaving her face. Such a person is a pleasure to draw and gives you a good opportunity of demonstrating the way that a person's habitual expressions eventually are marked permanently onto the lines of the older face.

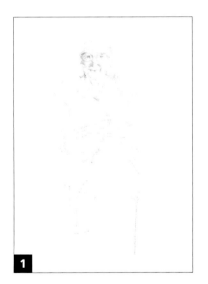

1. This pose was chosen primarily to be comfortable for the sitter. Because it is easily held, it offers a chance to make quite a thorough drawing. Take your time, therefore, in making your first marks accurate.

2. Athough, as always, you should work across the whole drawing, where character is the prime concern, the face is going to assume dominance. Look for the physical ways in which the facial expression is manifested.

3. The gentle twist, and slight slump, of the figure make the pose look comfortable and relaxed, rather than rigid and forced. Look for clues to the underlying form in the shape of the folds in the clothing.

4. The bright expression and the relaxed position combine to communicate the character of this lady. A strong and honest drawing will flatter your subject far more than will circumspection about drawing wrinkles, so don't be nervous about describing the physical signs of ageing – the character will shine through these.

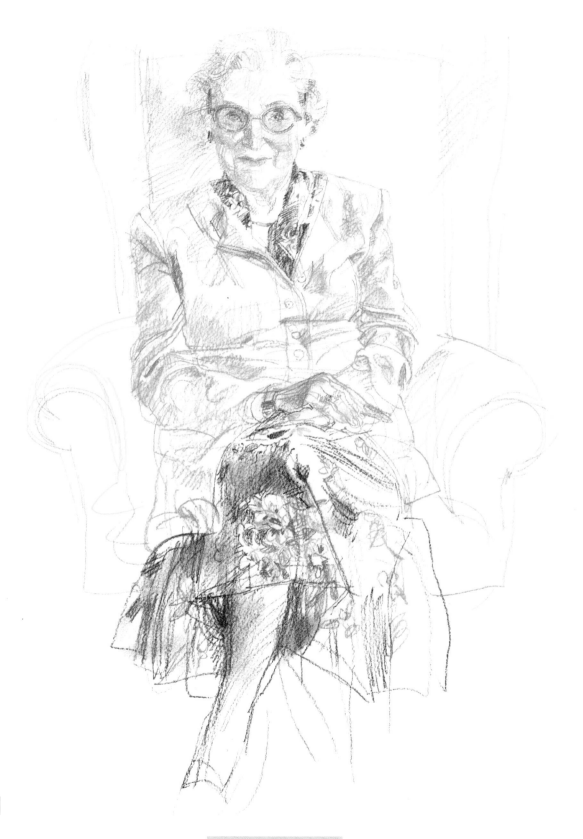

4

ELDERLY GENTLEMAN

*F*OR THIS project we suggest that you look for a model of a similar age to the lady who featured in the previous project – 70 or more years old. Although, as has been emphasized before, the amount of ageing in a face will vary hugely from individual to individual, there should be plenty of character revealed in a face that has looked out on life for 70 years or more.

Start this time with just a head and shoulders portrait and use whatever medium you feel comfortable with – at this stage you will have experimented with most media and can make your choice to match the subject. For the step-by-step demonstration illustrated, gouache or designer colour was used on a very heavy, unstretched piece of watercolour paper.

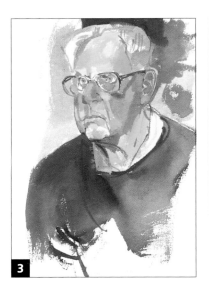

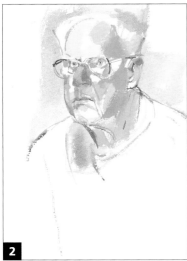

1. The first stage of this painting is to follow the standard approach of organizing where the main forms will appear on the page.

2. Develop the form conventionally. Even at this early stage though, characteristics of your subject may occur. In this case, the wide range of colours across the gentleman's face is evident.

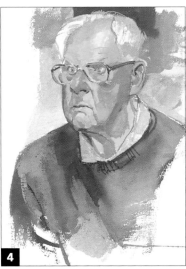

3. The introduction of the cool green of the jumper throws the warm hues of the face into sharper context.

4. It is important with any portrait to keep the form solid and the shapes in proportion. Examine your work and go back over it to correct the tonal range.

5. The energy and astuteness of this gentleman are clear in the finished painting. Let yourself be led by the characteristics of your subject as you discover them, but keep everything together with strong drawing.

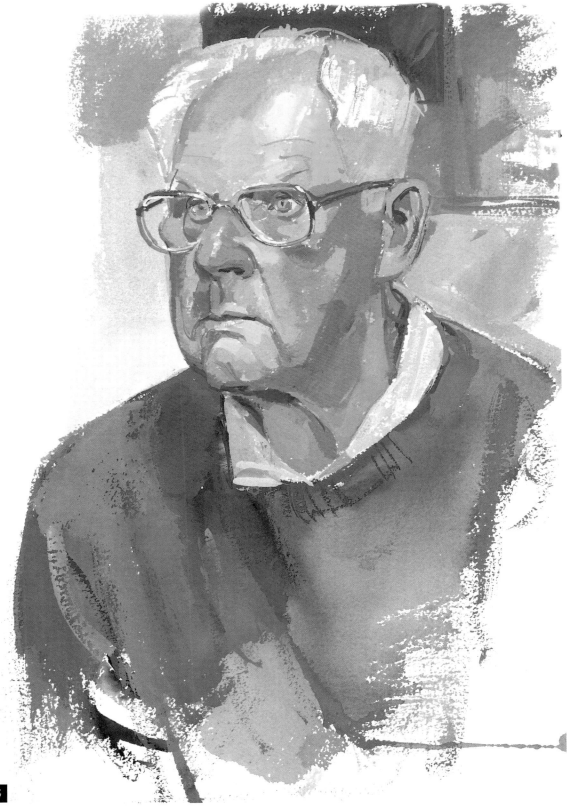

5

Mounting and Framing

*E*VEN IF you have no intention of framing and hanging your drawings, it is good to see them isolated from their surroundings by a clean-cut border.

Unless the drawing/painting is on a stretched canvas, which makes it difficult to make changes to its size, cutting a mount gives you a further opportunity to make adjustments to the composition. Just as described in project 48, use two pieces of L-shaped card to try out various ways of cropping and framing and when you are happy with the arrangement, measure the frame and use

these dimensions for cutting a mount. There are no absolute rules about the width that a mount should be: fashions change continually in suggesting what width and colour and presence or absence of embellishments is desirable and acceptable.

Generally, however, the rule is that the deepest margin should be at the base of the mount, somewhat narrower widths at each side with the narrowest width at the top. Of course this does not always work well with the size of a chosen frame, and you will often see side margins that are wider than the base margin, so the rule is not immutable.

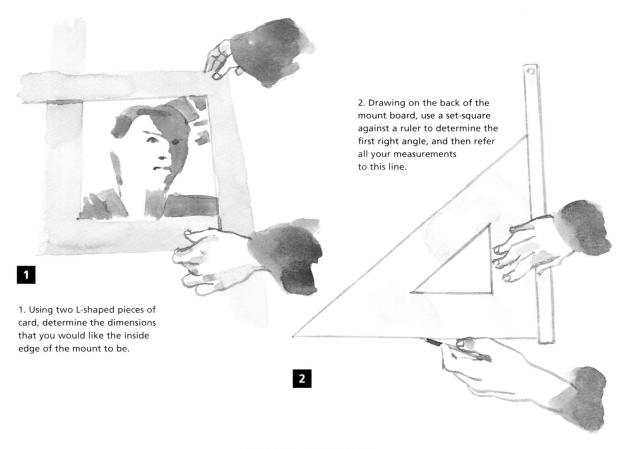

2. Drawing on the back of the mount board, use a set-square against a ruler to determine the first right angle, and then refer all your measurements to this line.

1

1. Using two L-shaped pieces of card, determine the dimensions that you would like the inside edge of the mount to be.

2

However, it will almost always look uncomfortable to have the narrowest margin at the base – the picture will seem to be sliding out of the frame.

Whatever proportions you choose, it is always best to be generous in the widths of the mount. It is much better to err on the side of over-generosity in mount width; nothing looks worse than a narrow mean-looking mount.

Oil paintings – unlike drawings and watercolours – are generally framed unmounted.

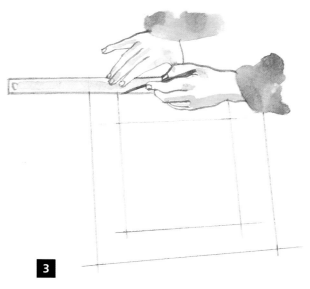

3

3. Make sure that you 'overdraw' all your lines, and make your measurements as far apart as possible, to minimize any errors.

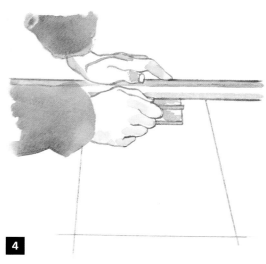

4

4. Still on the back of the board, use a bevel mount cutter to cut out the centre piece. Remember to hold everything as securely as you can.

5

5. The centre should drop out cleanly. If it does not, don't force it – just release any uncut corners with a scalpel.

6

6. Place your mount on the drawing, and arrange it to your satisfaction, securing it with paper tape on the back.

INDEX